This Book Belongs To

W9-BYG-227

Thank You

DOH!!

SIMPSONS

COMICS

WINGDING

HarperPerennial

To the loving memory of Snowball I:
If you're in kitty heaven, we hope you're
sitting in the catbird seat.

FIRST EDITION

ISBN 0-06-095245-7

97 98 99 00 01 RRD 10 9 8 7 6 5 4 3 2 1

Publisher: MATT GROENING
Managing Editor: JASON GRODE
Art Director / Editor: BILL MORRISON
Book Design: MARILYN FRANDSEN
Legal Guardian: SUSAN GRODE

Contributing Artists:
TIM BAVINGTON, JEANNINE CROWELL BLACK,
CHRIS CLEMENTS, LUIS ESCOBAR,
STEPHANIE GLADDEN, TIM HARKINS, NATHAN KANE,
BILL MORRISON, PHIL ORTIZ , STEVE STEERE, JR.

Contributing Writers:
TRACY BERNA, GARY GLASBERG, JIM LINCOLN, BILL MORRISON,
JEFF ROSENTHAL, DAN STUDNEY, SIB VENTRESS

CONTENTS

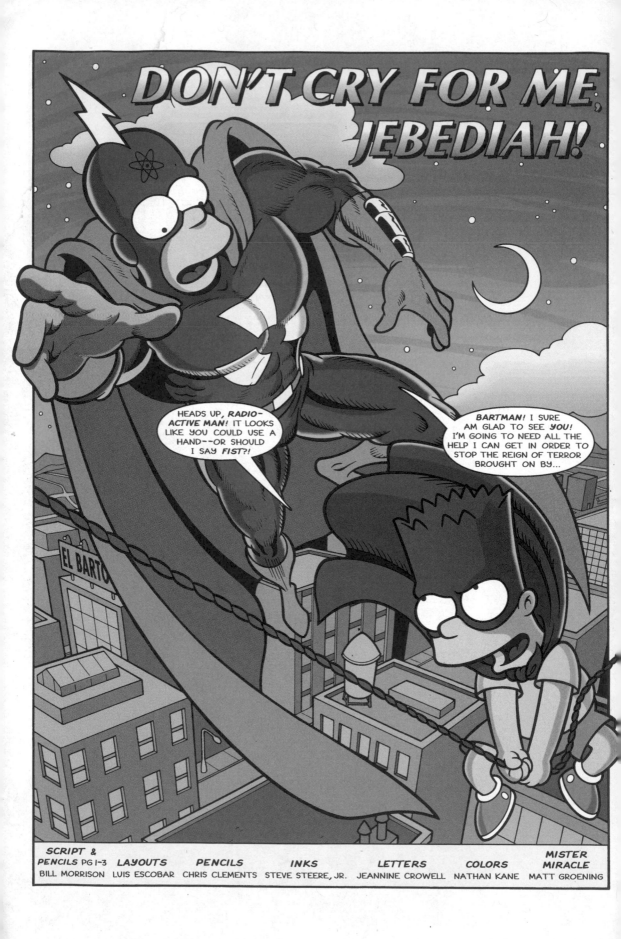

SCRIPT &
PENCILS PG 1-3 LAYOUTS PENCILS INKS LETTERS COLORS MISTER
 MIRACLE
BILL MORRISON LUIS ESCOBAR CHRIS CLEMENTS STEVE STEERE, JR. JEANNINE CROWELL NATHAN KANE MATT GROENING

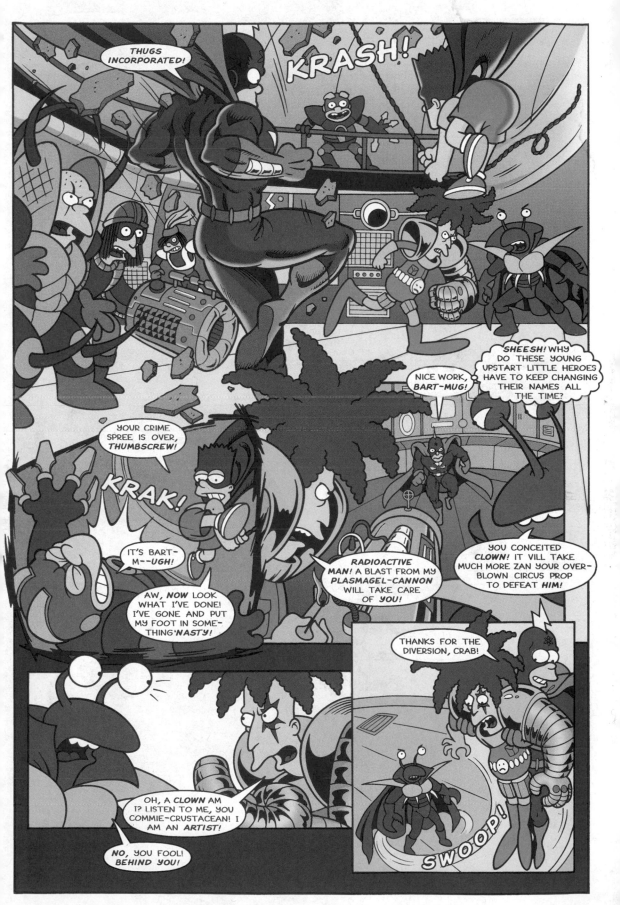

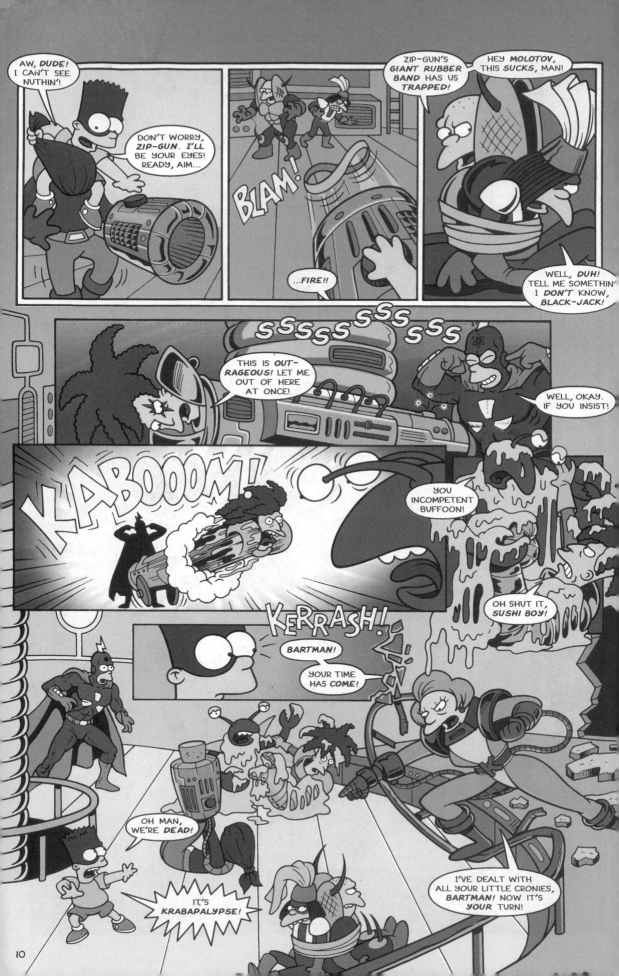

YOUR TIME HAS *COME*, BART!

WUH?

I *SAID* IT'S YOUR TURN! BEFORE YOU DRIFTED OFF TO PLANET BART, YOU MAY RECALL THAT I WAS HANDING OUT ASSIGNMENTS FOR EACH STUDENT TO WRITE ABOUT A FAMOUS HERO.

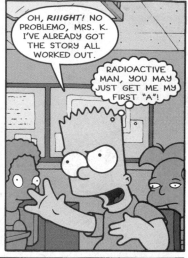

OH, *RIIIGHT!* NO PROBLEMO, MRS. K. I'VE ALREADY GOT THE STORY ALL WORKED OUT.

RADIOACTIVE MAN, YOU MAY JUST GET ME MY FIRST "A"!

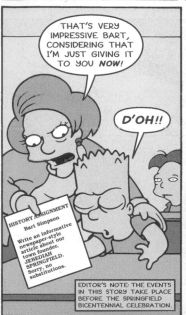

THAT'S VERY IMPRESSIVE BART, CONSIDERING THAT I'M JUST GIVING IT TO YOU *NOW!*

D'OH!!

HISTORY ASSIGNMENT
Bart Simpson

Write an informative newspaper-style article about our town founder, JEBEDIAH SPRINGFIELD. Sorry, no substitutions.

EDITOR'S NOTE: THE EVENTS IN THIS STORY TAKE PLACE BEFORE THE SPRINGFIELD BICENTENNIAL CELEBRATION.

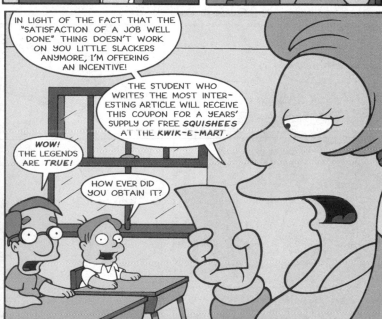

IN LIGHT OF THE FACT THAT THE "SATISFACTION OF A JOB WELL DONE" THING DOESN'T WORK ON YOU LITTLE SLACKERS ANYMORE, I'M OFFERING AN INCENTIVE!

THE STUDENT WHO WRITES THE MOST INTER- ESTING ARTICLE WILL RECEIVE THIS COUPON FOR A YEARS' SUPPLY OF FREE *SQUISHEES* AT THE *KWIK-E-MART.*

WOW! THE LEGENDS ARE *TRUE!*

HOW EVER DID YOU OBTAIN IT?

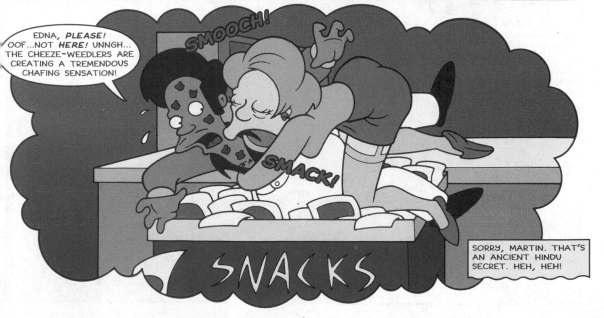

EDNA, *PLEASE!* OOF...NOT *HERE!* UNNGH... THE CHEEZE-WEEDLERS ARE CREATING A TREMENDOUS CHAFING SENSATION!

SMOOCH!

SMACK!

SNACKS

SORRY, MARTIN. THAT'S AN ANCIENT HINDU SECRET. HEH, HEH!

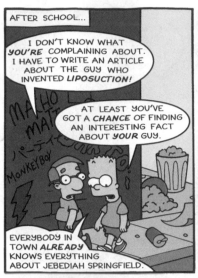

AFTER SCHOOL...

I DON'T KNOW WHAT *YOU'RE* COMPLAINING ABOUT. I HAVE TO WRITE AN ARTICLE ABOUT THE GUY WHO INVENTED *LIPOSUCTION*!

AT LEAST YOU'VE GOT A *CHANCE* OF FINDING AN INTERESTING FACT ABOUT *YOUR* GUY.

EVERYBODY IN TOWN *ALREADY* KNOWS EVERYTHING ABOUT JEBEDIAH SPRINGFIELD.

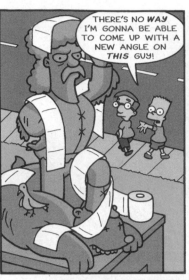

THERE'S NO *WAY* I'M GONNA BE ABLE TO COME UP WITH A NEW ANGLE ON *THIS* GUY!

I MAY AS WELL FACE IT. THERE'S NO SUCH THING AS A FREE SQUISHEE FOR BARTHOLOMEW J. SIMPSON.

I WONDER IF THE NEW ISSUE OF *LADY FUNGICIDE* IS IN YET.

HEY MILHOUSE, CHECK *THIS* OUT!

I'M NOT KNOCKING COMICS, BUT THIS IS EVEN *BETTER*!

IT'S ALL *TRUE*!

THE WEEKLY WORLD SCUTTLEBUTT

FAMOUS CARTOONIST SAYS, "I PARTIED WITH SPACE ALIENS!"

GHOST OF TV'S RADIOACTIVE MAN STILL HAUNTS BORDELLO; NOW SUSHI BAR.

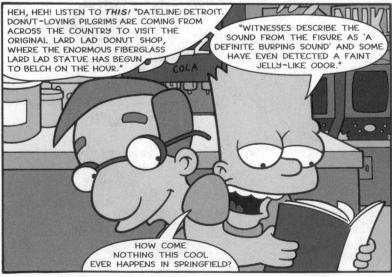

HEH, HEH! LISTEN TO *THIS*! "DATELINE: DETROIT. DONUT-LOVING PILGRIMS ARE COMING FROM ACROSS THE COUNTRY TO VISIT THE ORIGINAL LARD LAD DONUT SHOP, WHERE THE ENORMOUS FIBERGLASS LARD LAD STATUE HAS BEGUN TO BELCH ON THE HOUR."

"WITNESSES DESCRIBE THE SOUND FROM THE FIGURE AS 'A DEFINITE BURPING SOUND' AND SOME HAVE EVEN DETECTED A FAINT JELLY-LIKE ODOR."

HOW COME NOTHING THIS COOL EVER HAPPENS IN SPRINGFIELD?

HMMM...*WAIT* A MINUTE! THIS GIVES ME AN *IDEA*!

THAT EVENING...

SO I SHED TO :CHOMP: MISHTER BLURNSH, LISHEN YOU, BIG :URP: FURGLE MARFER :SMACK: I'M DRN TAKIN YUR :BLORCH: CRUD!

:GULP: YOU SHOULDA BEEN THERE MARGE! IT WAS *GREAT!* THEN LENNY WOKE ME UP AND IT WAS TIME TO PUNCH OUT!

THAT'S *NICE*, HOMEY. AND HOW WAS YOUR DAY AT SCHOOL, BART?

CAN'T TALK... STUDYING.

Yes, I Did
by
Jebediah
Springfield

TICK TOCK!

TICK TOCK!

CHREEP! CHREEP! CHREEP!

DRIP! DRIP! DRIP! DRIP!

13

UMM...EXCUSE ME, BART, BUT WOULD YOU MIND REPEATING THAT?

I SAID I'M STUDYING.

CHOKE!

GLUK!

GLURG!

KOFF!

KOFF!

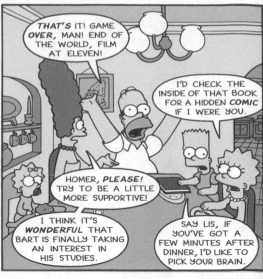

THAT'S IT! GAME OVER, MAN! END OF THE WORLD, FILM AT ELEVEN!

I'D CHECK THE INSIDE OF THAT BOOK FOR A HIDDEN COMIC IF I WERE YOU.

HOMER, PLEASE! TRY TO BE A LITTLE MORE SUPPORTIVE!

I THINK IT'S WONDERFUL THAT BART IS FINALLY TAKING AN INTEREST IN HIS STUDIES.

SAY LIS, IF YOU'VE GOT A FEW MINUTES AFTER DINNER, I'D LIKE TO PICK YOUR BRAIN.

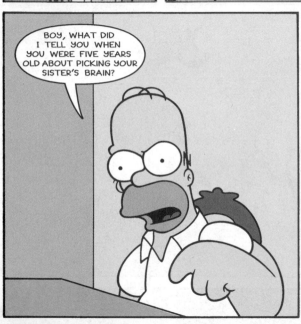

BOY, WHAT DID I TELL YOU WHEN YOU WERE FIVE YEARS OLD ABOUT PICKING YOUR SISTER'S BRAIN?

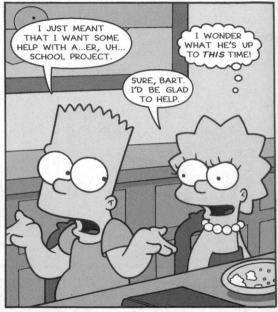

I JUST MEANT THAT I WANT SOME HELP WITH A...ER, UH... SCHOOL PROJECT.

I WONDER WHAT HE'S UP TO THIS TIME!

SURE, BART. I'D BE GLAD TO HELP.

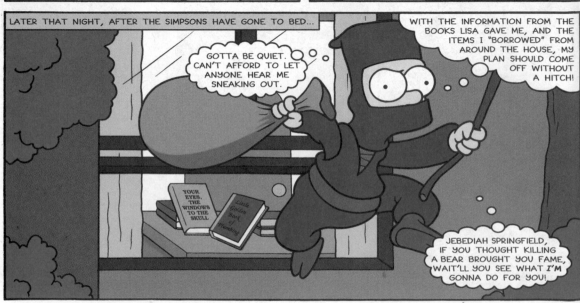

LATER THAT NIGHT, AFTER THE SIMPSONS HAVE GONE TO BED...

GOTTA BE QUIET. CAN'T AFFORD TO LET ANYONE HEAR ME SNEAKING OUT.

WITH THE INFORMATION FROM THE BOOKS LISA GAVE ME, AND THE ITEMS I "BORROWED" FROM AROUND THE HOUSE, MY PLAN SHOULD COME OFF WITHOUT A HITCH!

YOUR EYES, THE WINDOWS TO THE SKULL

Little Golden Book of Plumbing

JEBEDIAH SPRINGFIELD, IF YOU THOUGHT KILLING A BEAR BROUGHT YOU FAME, WAIT'LL YOU SEE WHAT I'M GONNA DO FOR YOU!

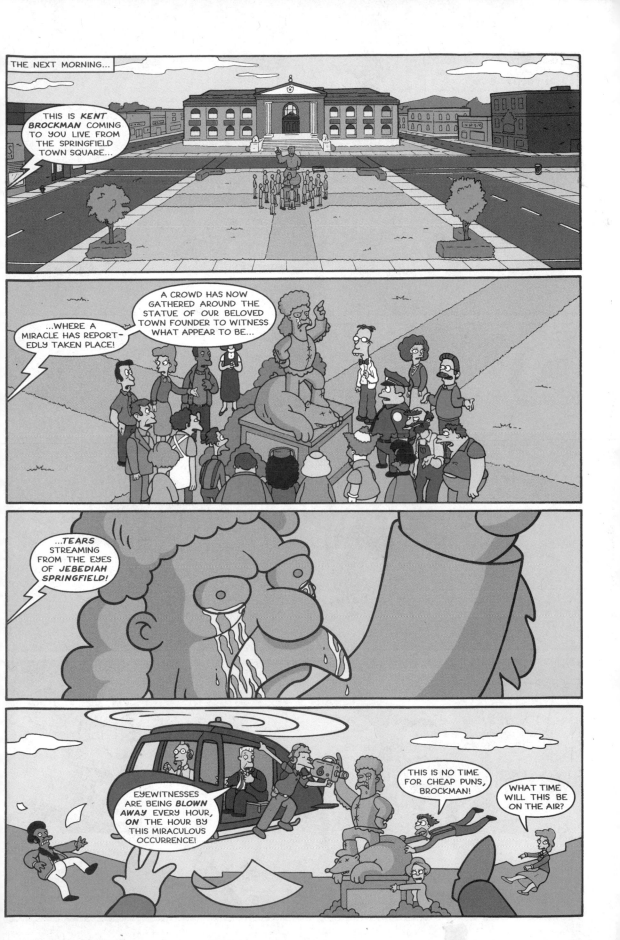

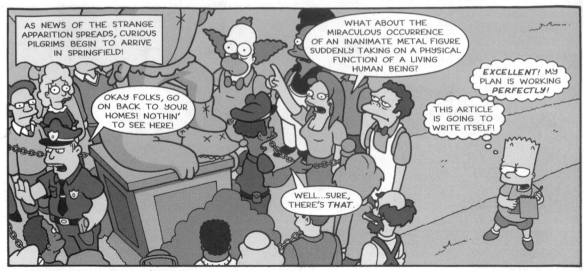

AS NEWS OF THE STRANGE APPARITION SPREADS, CURIOUS PILGRIMS BEGIN TO ARRIVE IN SPRINGFIELD!

OKAY FOLKS, GO ON BACK TO YOUR HOMES! NOTHIN' TO SEE HERE!

WHAT ABOUT THE MIRACULOUS OCCURRENCE OF AN INANIMATE METAL FIGURE SUDDENLY TAKING ON A PHYSICAL FUNCTION OF A LIVING HUMAN BEING?

EXCELLENT! MY PLAN IS WORKING PERFECTLY!

THIS ARTICLE IS GOING TO WRITE ITSELF!

WELL...SURE, THERE'S THAT.

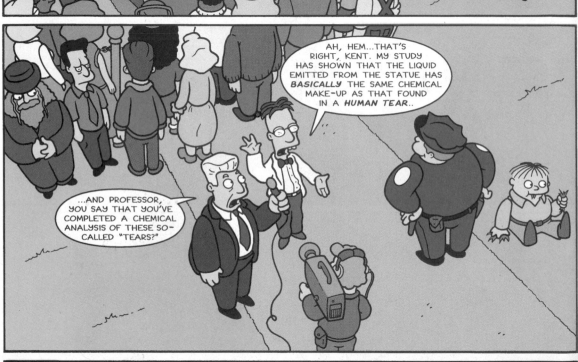

AH, HEM...THAT'S RIGHT, KENT. MY STUDY HAS SHOWN THAT THE LIQUID EMITTED FROM THE STATUE HAS BASICALLY THE SAME CHEMICAL MAKE-UP AS THAT FOUND IN A HUMAN TEAR..

...AND PROFESSOR, YOU SAY THAT YOU'VE COMPLETED A CHEMICAL ANALYSIS OF THESE SO-CALLED "TEARS?"

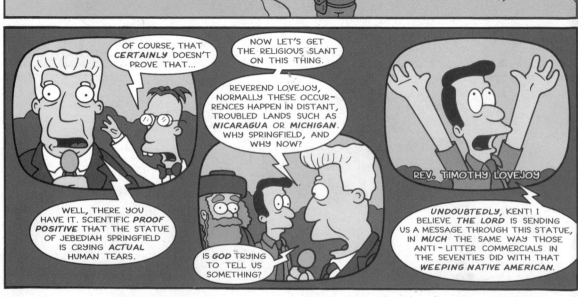

OF COURSE, THAT CERTAINLY DOESN'T PROVE THAT...

WELL, THERE YOU HAVE IT. SCIENTIFIC PROOF POSITIVE THAT THE STATUE OF JEBEDIAH SPRINGFIELD IS CRYING ACTUAL HUMAN TEARS.

NOW LET'S GET THE RELIGIOUS SLANT ON THIS THING.

REVEREND LOVEJOY, NORMALLY THESE OCCUR-RENCES HAPPEN IN DISTANT, TROUBLED LANDS SUCH AS NICARAGUA OR MICHIGAN. WHY SPRINGFIELD, AND WHY NOW?

IS GOD TRYING TO TELL US SOMETHING?

REV. TIMOTHY LOVEJOY

UNDOUBTEDLY, KENT! I BELIEVE THE LORD IS SENDING US A MESSAGE THROUGH THIS STATUE, IN MUCH THE SAME WAY THOSE ANTI-LITTER COMMERCIALS IN THE SEVENTIES DID WITH THAT WEEPING NATIVE AMERICAN.

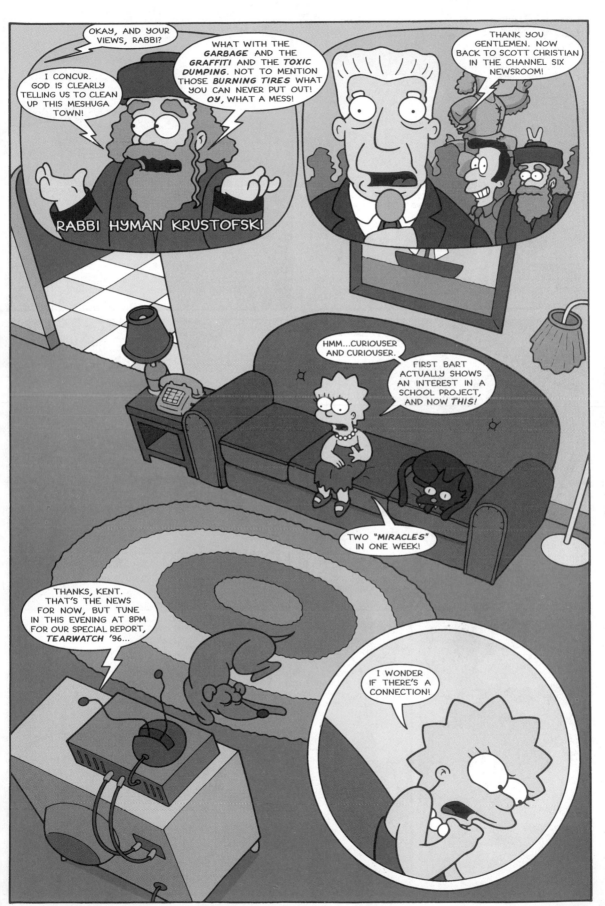

THE NEXT MORNING, AFTER BREAKFAST...

GEE BART, SHOULDN'T YOU BE WORKING ON YOUR *HISTORY PAPER*?

CHECK YOUR CALENDAR, LIS! IT'S *SATURDAY*!

LISTEN BART, WE NEED TO TALK. IT'S ABOUT THE STATUE OF JEBEDIAH.

UH, OH! SHE KNOWS SOMETHING. BETTER AVOID CONFRONTATION!

UH...SORRY. NO TIME. YOU WERE RIGHT. I *SHOULD* BE WORKING ON MY ARTICLE. I THINK I'LL GO TO THE LIBRARY AND DO SOME RESEARCH!

BWA-HA-HA! MAN, THAT WAS *CLOSE*!

I GUESS I'LL CHECK IN ON MY LITTLE PROJECT.

MOST OF THE EXCITEMENT HAS PROBABLY DIED DOWN BY NOW.

WHAT THE...

WHO THE...

HOW THE...

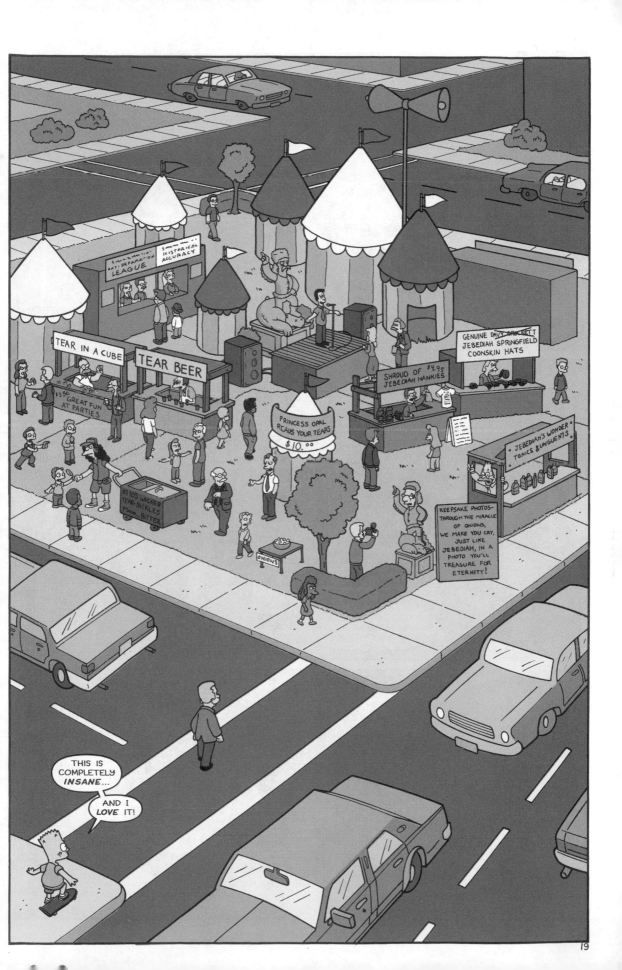

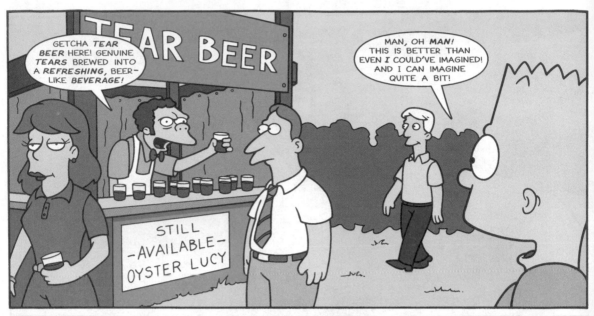

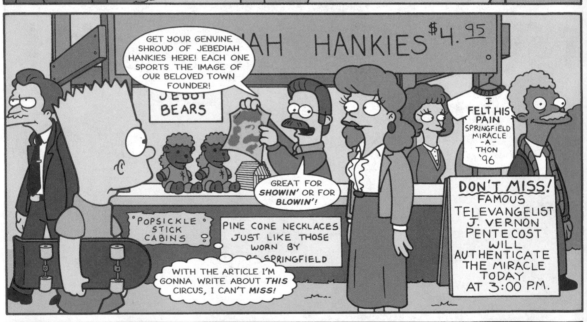

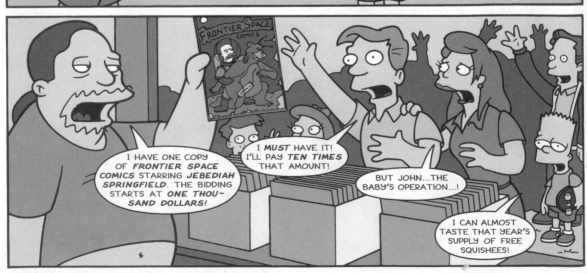

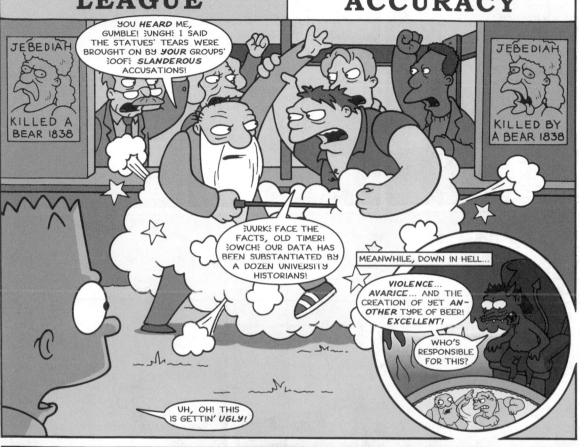

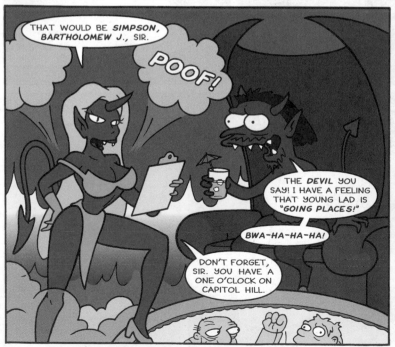

BACK AT 742 EVERGREEN TERRACE...

I CAN'T SHAKE THE FEELING THAT THERE'S A LINK BETWEEN BART AND THIS SO-CALLED MIRACLE. BUT WHAT?

COME ON LISA... *CONCENTRATE!* YOU'VE GOT HOMEWORK TO DO. NEVER MIND ABOUT BART!

DARN! WHAT'S *WRONG* WITH ME? WHY AM I SO *TENSE?* AND WHY CAN'T I *FOCUS?*

SNAP!

WAIT A MINUTE. IT'S A LITTLE TOO *QUIET* IN HERE.

OF COURSE! MY FOUNTAIN ISN'T RUNNING! THAT EXPLAINS THE POOR *CH'I ENERGY* IN THE ROOM! NO WONDER I'VE BEEN SO AGITATED!

THE WATER PUMP IS *MISSING!* I WONDER WHO WOULD HAVE--

BART!!!

22

SOON...

THIS IS EVEN CRAZIER IN PERSON THAN IT IS ON T.V.! I'D BETTER ACT QUICKLY!

GOD CAME TO SPRINGFIELD AND ALL I GOT WAS THIS LOUSY T-SHIRT

UNLESS I MISS MY GUESS, I'M GOING TO LOOK BEHIND THIS BUSH AND FIND...

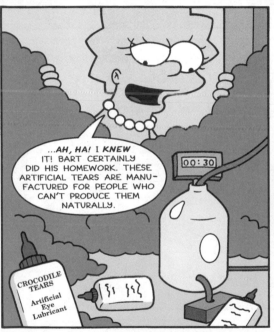

...AH, HA! I KNEW IT! BART CERTAINLY DID HIS HOMEWORK. THESE ARTIFICIAL TEARS ARE MANUFACTURED FOR PEOPLE WHO CAN'T PRODUCE THEM NATURALLY.

CROCODILE TEARS

Artificial Eye Lubricant

00:30

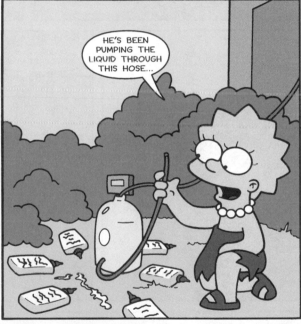

HE'S BEEN PUMPING THE LIQUID THROUGH THIS HOSE...

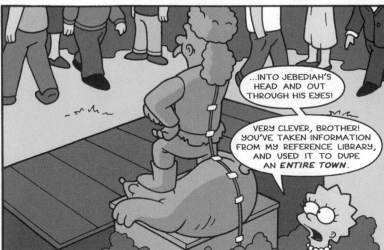

...INTO JEBEDIAH'S HEAD AND OUT THROUGH HIS EYES!

VERY CLEVER, BROTHER! YOU'VE TAKEN INFORMATION FROM MY REFERENCE LIBRARY, AND USED IT TO DUPE AN ENTIRE TOWN.

BUT THIS MADNESS HAS TO END BEFORE SOMEONE GETS HURT! AND SINCE I'M AN UNWITTING ACCOMPLICE, I'D BETTER FIND A WAY TO DO IT!

LATER THAT AFTERNOON...

GREETINGS FELLOW JEBEDILLOPHILES!

TODAY WE'RE PLEASED AS PUNCH TO WELCOME OUR HONORED GUEST, THAT HUM-DIDDLY-DINGER OF A T.V. EVANGELIST, *DR. J. VERNON PENTECOST!*

CLAP!

CLAP!

CLAP!

CLAP!

CLAP!

ALL-*RIIIGHT?!*

WOO HOO!

VERNON *ROCKS!*

AND NOW, DOCTOR PENTECOST WILL WITNESS, AND HOPEFULLY AUTHENTICATE THE MIRACLE. GET READY NOW! THREE...TWO...ONE...

...*BINGO!* HUH?!

FLOOSH!

GLUB!

ALRIGHT-- *FREEZE,* STATUE!

THAT'S A FLAGRANT VIOLATION OF OUR *ANTI-SPITTING ORDINANCE!*

IT'S ALIVE! ALIVE!

FWOOP!

YAAAH!

MMMMM... BEER!

WHAT?!!

HALLELUJAH! I BELIEVE!

¡UURRRP!¿

UH...I MEAN... *BEER!* THIS IS NO *MIRACLE!* IT'S A MORAL *OUTRAGE!*

HE'S RIGHT! THE GOOD LORD USED *WINE* IN HIS MIRACLES, BUT BEER? *NEVER!*

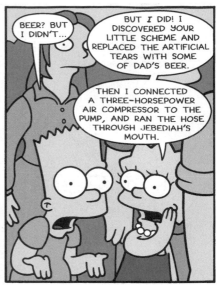

BEER? BUT I DIDN'T...

BUT *I* DID! I DISCOVERED YOUR LITTLE SCHEME AND REPLACED THE ARTIFICIAL TEARS WITH SOME OF DAD'S BEER.

THEN I CONNECTED A THREE-HORSEPOWER AIR COMPRESSOR TO THE PUMP, AND RAN THE HOSE THROUGH JEBEDIAH'S MOUTH.

I'M SORRY I HAD TO FOIL YOUR BRILLIANT PLAN BART, BUT THINGS WERE GETTING WAY OUT OF HAND.

BUT...THE DREAM... MY BEAUTIFUL SQUISHEE DREAM...

IT'S ALL A BIG *FAKE!*

INDEED. I WONDER WHO COULD HAVE PERPETRATED SUCH A DEVILISH HOAX.

HEY EVERYBODY! LOOKY WHAT *I* FOUND BEHIND THE STATUE!

HMMM...

IT'S SOME KINDA PUMPING GIZMO... PRETTY CONVENIENT FOR *SOMEBODY* THAT WE NEVER BOTHERED TO CHECK FOR GIZMOS AND THINGAMABOBS!

AND LOOK! A BEER CAN BELONGING TO *BART SIMPSON'S* FATHER!

Duff
DO NOT TOUCH PROPERTY OF HOMER SIMPSON
BEER

WOO HOO! THAT'S *ME!* TOSS ME A TALL COOL ONE, SKINNER!

THEY'RE *EMPTY,* MR. SIMPSON!

NOOOOO! :SOB: DEAR GOD IN HEAVEN, NOT THE BEER! *WHY?* WHY *ME?* :CHOKE: IT'S JUST NOT *FAIR!*

WELL, SINCE IT'S PRETTY APPARENT THAT SIMPSON WOULD NEVER WASTE A DROP OF BEER, THE AUTHOR OF THIS SCHEME CAN BE ONLY ONE PERSON...

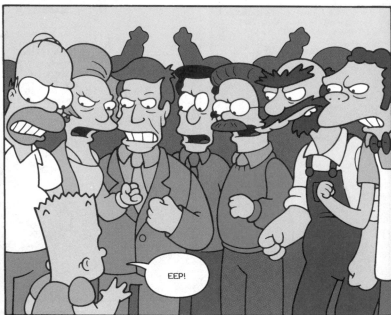

EEP!

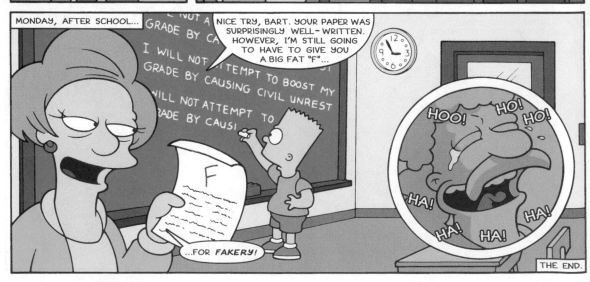

MONDAY, AFTER SCHOOL...

NICE TRY, BART. YOUR PAPER WAS SURPRISINGLY WELL-WRITTEN. HOWEVER, I'M STILL GOING TO HAVE TO GIVE YOU A BIG FAT "F"...

...FOR *FAKERY!*

HOO! HO! HO! HA! HA! HA! HA!

THE END.

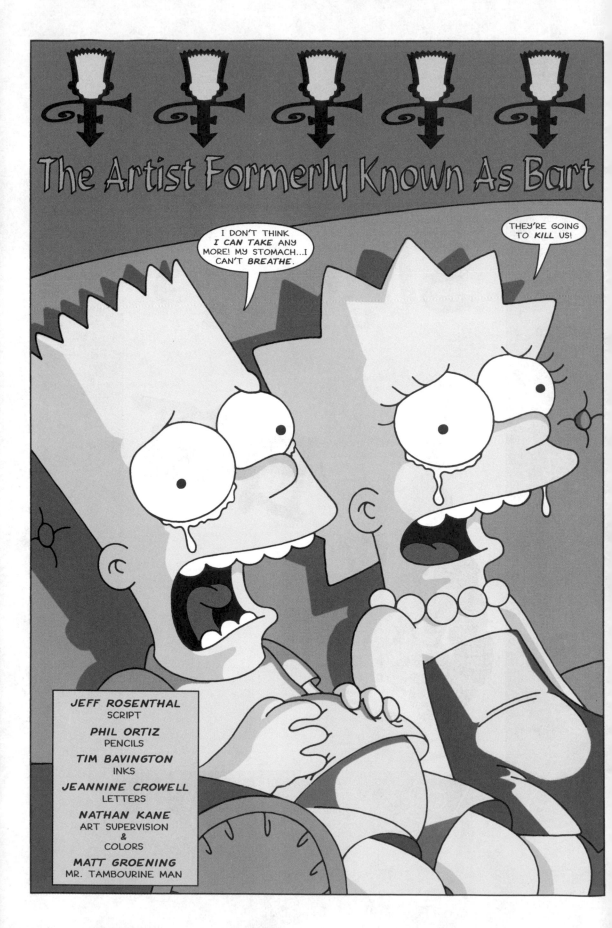

I CAN'T POSSIBLY *HANDLE TWENTY-ONE* MORE MINUTES OF THIS TWISTED GENIUS. MY SIDES ARE ABOUT TO IMPLODE FROM THE *BLADDER-BURSTING* OPENING SEQUENCE ALONE.

SCRATCHY $3.99 lb.

PACE YOURSELF, BART. DON'T FORGET SATURDAY NIGHT IS THE HOUR-LONG *KRUSTY THE KLOWN* ANNIVERSARY SHOW, LIVE FROM THE SPRINGFIELD AMPHITORIUM WITH SPECIAL MUSICAL GUEST, ‡SIGH‡ *BIFF WESTWOOD.*

ZAP

HEY, WHAT THE--

MOM! WE WERE *WATCHING* THAT!

I'M SORRY, BUT YOU KIDS WATCH FAR TOO MUCH TELE-VISION. LISA, YOUR FATHER IS OUT AT AN *IMPORTANT MEETING*, SO WHY DON'T YOU PRACTICE YOUR *SAXOPHONE*. AND BART, DON'T YOU HAVE A *HISTORY TEST* TO STUDY FOR?

AW, C'MON, MOM. HISTORY IS ABOUT A BUNCH OF *HAS-BEENS*. SHOULDN'T I BE ALLOWED TO EXPERIENCE THE *PRESENT* AND LOOK FORWARD TO THE *FUTURE* WITHOUT DWELLING ON THE *PAST*?

YOU'RE RIGHT, BART. I DON'T WANT YOU TO DWELL ON THE *PAST*, WHEN I'VE LET YOU WATCH TELEVISION UNTIL YOUR EYES WERE *BLOODSHOT*. I WANT YOU TO GO TO YOUR ROOM *PRESENTLY*, AND STUDY FOR THE HISTORY TEST IN YOUR *NEAR FUTURE!* I'LL BE UP IN AN HOUR TO CHECK ON YOU.

YES, MA'AM.

ERMA BOMBECK'S GOT *NOTHING* ON ME.

GROAN: HERE GOES: "THE ARCHDUKE FERDINAND WAS ASSASSINATED BY A SERBIAN NATIONALIST IN YUGOSLAVIA... BLAH, BLAH, BLAH." THIS IS SO LAME.

I'VE NEVER HEARD OF *YUGOSLAVIA*. IT PROBABLY DOESN'T EVEN *EXIST ANYMORE*.

I WONDER WHAT RADIOACTIVE MAN WOULD DO IF HE WERE TRAPPED IN HIS ROOM, *FORCED* TO READ THIS USELESS JUNK.

REMEMBER, KIDS, *NEVER* QUESTION AUTHORITY!

GROAN:

COME ON, KRUSTY, DON'T LET ME DOWN.

HEY-HEY-HEY!

IF YOU PULL THAT AGAIN, NEITHER KRUSTY THE KLOWN NOR KRUSTY INCORPORATED MAY BE HELD LIABLE FOR ANY POSSIBLE DAMAGE...

...REAL OR IMAGINED, TO YOUR INDEX FINGER, ANY OTHER PART OF YOUR BODY OR THIS KRUSTY PRODUCT.

GROAN:

HMM...MOM'S COMING UP IN AN HOUR TO CHECK ON ME.

JUST ENOUGH TIME TO FINISH A CHERRY SQUISHEE AND RETURN FROM THE KWIK-E-MART WITHOUT MY ABSENCE BEING DETECTED.

THAT'S VERY... UM...*SOOTHING*, LISA.

HEY! WHAT'S BART UP TO?!

MEANWHILE, OUTSIDE SPRINGFIELD AIRPORT...

IN HONOR OF BIFF WESTWOOD, I PROCLAIM THE SLOGAN OF THE DAY TO BE, "LOCK AND LOAD!"

AH, SIR, THAT'S FOR TOMORROW WHEN WE GIVE CLINT *EASTWOOD* THE KEY TO THE CITY.

ER...OF COURSE. TODAY'S SLOGAN IS... "ROCK THAT ROLL!"

GATE 15

IT'S ROCK *AND* ROLL, JERK!

SPRINGFIELD ROCKS!

BIFF 4-EVER!

I ♥ BIFF!

BIFF THANKS YOU FOR YOUR SUPPORT-- WATCH HIM ON THE BIG *KRUSTY SPECIAL.*

NOW, IF YOU'LL EXCUSE US, BIFF IS LATE FOR HIS CHAKRA ADJUSTMENT.

SEND BACK-UP...OOH, THAT TICKLES.

QUICK, BIFF! GET IN THE LIMO AND I'LL MEET YOU BACK AT THE HOTEL.

BIFF WESTWOOD? NOW THAT'S A *STORY!*

WELCOME HOOTIE & THE BLOWFISH

WHEEE!!!

VROOOM!

31

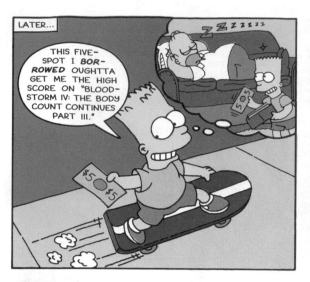

LATER...

THIS FIVE-SPOT I *BORROWED* OUGHTTA GET ME THE HIGH SCORE ON "BLOODSTORM IV: THE BODY COUNT CONTINUES PART III."

I'LL JUST BE A MINUTE.

HERE YOU ARE, BART SIMPSON. DRINK IT SLOWLY, AS I FEAR THE CONSEQUENCES OF *BRAIN FREEZE* ON A PERSONAGE OF YOUR AGE.

DON'T SWEAT IT, APU. THERE ISN'T A SQUISHEE ON EARTH THAT CAN FREEZE THIS DIABOLICAL BRAIN.

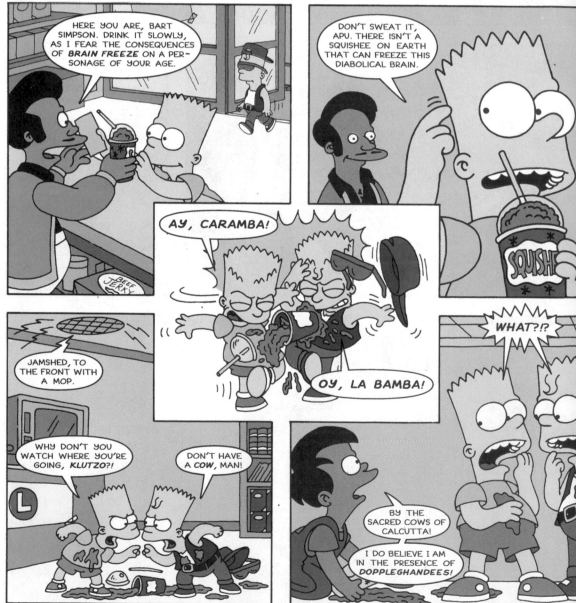

AY, CARAMBA!

OY, LA BAMBA!

JAMSHED, TO THE FRONT WITH A MOP.

WHY DON'T YOU WATCH WHERE YOU'RE GOING, *KLUTZO*?!

DON'T HAVE A *COW*, MAN!

WHAT?!?

BY THE SACRED COWS OF CALCUTTA!

I DO BELIEVE I AM IN THE PRESENCE OF *DOPPLEGHANDEES*!

A *DOPPLEGHANDI* IS YOUR EXACT DOUBLE. ONE WHO EMBODIES THE SAME PHYSICAL CHARACTERISTICS AS YOURSELF. SOME CALL IT "YOUR IMAGE OF SPITTING."

IT IS SAID THAT SHOULD THESE TWO BEINGS MEET, THERE IS THE CHANCE THAT THE UNIVERSE WILL COLLAPSE IN ON ITSELF CREATING A NEW UNIVERSE WHEREIN ALL PEOPLES WILL BE TURNED INTO THREE-HEADED YAKS.

COOL.

WEIRD.

PICK EGG

EERILY, YOUR *VOICES* EVEN SOUND THE *SAME*. NOW, IF YOU'LL EXCUSE ME, I MUST HELP MY UNCLE TO ANOINT THE NACHO CHEESE DISPENSER.

SORRY ABOUT SPILLING YOUR SQUISHEE. CAN I BUY YOU ANOTHER ONE?

I NEVER TURN DOWN THE FREEBIES.

$100

I WOULD *LOVE* TO HAVE YOUR LIFE. YOU GET TO BE ON TELEVISION AND MAKE TRUCKLOADS OF MONEY BY MERCHANDISING YOUR NAME AND LIKENESS. YOU EVEN HAVE YOUR OWN COMIC BOOK. I CAN'T IMAGINE WHAT THAT WOULD BE LIKE.

SURE, IT HAS ITS MOMENTS, BUT THERE ARE DRAWBACKS, TOO. I'M NEVER IN ONE TOWN LONG ENOUGH TO MAKE ANY FRIENDS. I CAN'T GO ANYWHERE WITHOUT BEING MOBBED. I NEVER GET A HOME-COOKED MEAL.

I'M SO BUSY DOING MAGAZINE, TELEVISION, AND RADIO INTERVIEWS THAT I HAVE NO TIME FOR MY REAL INTEREST IN LIFE, THE STUDY OF HISTORY.

SOMETIMES I WISH I COULD TAKE A BREAK FROM IT ALL AND JUST BE A REGULAR KID FOR A COUPLE OF DAYS.

HOW DOES RIGHT NOW SOUND? C'MERE, I'VE GOT A PLAN.

NAB!

A FEW MINUTES LATER...

AW, NERTZ! I GUESS I *LOST* MORE THAN I THOUGHT...

...SO, YOUR HISTORY BOOKS ARE ON YOUR DESK, YOUR BEST FRIEND IS MILHOUSE, AND NEVER CALL YOUR FATHER, *DAD*, ALWAYS, *HOMER*.

AND I TELL ALL THE INTER-VIEWERS HOW MUCH I LOVE WHATEVER CITY I'M IN AND THANK MY RECORD COMPANY FOR LETTING ME MAKE THE "KIND OF MUSIC I WANT TO MAKE."

I'LL MEET YOU AT THE HOTEL SATURDAY NIGHT BEFORE THE KRUSTY GIG. BART, THANKS FOR GIVING ME THIS CHANCE TO BE A *REGULAR SCHMOE* FOR A FEW DAYS.

NO PROBLEMO. AND *GOOD LUCK* ON MY HISTORY TEST.

HEY, HOMER. CAN I GET A LIFT HOME?

HUH? WHAT'RE *YOU* DOING HERE?

I SNUCK OUT OF THE HOUSE...TO GET YOU *THIS*.

THE BOY *LOVES* ME!

HOOK, LINE, AND SPRINKLES.

TO THE SPRINGFIELD GRAND HOTEL, DRIVER.

REMEMBER, I DON'T TELL MARGE ABOUT YOU SNEAKING OUT OF THE HOUSE TO GET ME A DONUT, AND YOU DON'T TELL HER THAT I LOST MOST OF MY PAYCHECK BETTING ON MOE'S *COCKROACH GLADIATORS*. DEAL?

DEAL. THANKS, DA--, ER, I MEAN, HOMER.

MOMENTS LATER...

BART, THAT BETTER NOT BE A *COMIC BOOK* YOU'RE READING OR...

HI, MRS...ER...MOM. DID YOU KNOW THAT THE INVENTION OF THE COTTON GIN BY ELI WHITNEY IS LARGELY CONSIDERED TO BE THE HARBINGER OF THE INDUSTRIAL REVOLUTION?

HISTORY

NO, DEAR. I...UH... I DIDN'T KNOW THAT. GOOD NIGHT, DEAR.

'NIGHT.

NICE LADY. WACKED-OUT HAIRDO.

HOMEY, BART MADE ME *VERY PROUD* TONIGHT.

WHY? OH, NO! HE TOLD YOU THAT I WASN'T AT A MEETING AT ALL! THE AWFUL TRUTH IS THAT I GAMBLED MY PAY-CHECK AWAY. MARGE, CAN YOU EVER FORGIVE ME?

I MEANT BECAUSE BART STUDIED SO *HARD* FOR HIS HISTORY TEST. NOW, WHAT WAS THAT ABOUT *GAMBLING*?

NOTHING. I MUST HAVE BEEN...UH...*DREAMING*... UH...ABOUT WHATEVER IT WAS YOU THOUGHT I JUST SAID... HEH-HEH. G'NIGHT!

IT WAS SWELL OF BIFF TO GIVE ME HIS *POCKET CHANGE*. LET'S SEE WHAT A COUPLE OF THESE BABIES'LL GET ME.

BZZHT!

DRIVER, HOW FAST CAN ONE OF THESE STRETCH LIMOS GO?

LET'S FIND OUT, MR. WESTWOOD!

BUCKLE-UP, IT'S THE LAW!

SWOOSH!

POLICE

WHOA! I THINK WE'VE GOT OURSELVES A *SPEED DEMON*.

115 AND CLIMBING, MR. WESTWOOD.

COOL.

GOSH, I GUESS I WAS WRONG. THANK GOODNESS WE HAVE THESE NEW LASER GUN DEALIES. LAST THING I NEED IS A *FALSE ARREST* RAP TO SULLY MY RECORD.

35 MPH

AT THE HOTEL...

Springfield GRAND 777

WELCOME, MR. WESTWOOD!

YOUR PARTY AWAITS YOU IN THE PENTHOUSE SUITE.

THIS IS SOME FLOPHOUSE.

EXCELLENT, MY GOOD MAN.

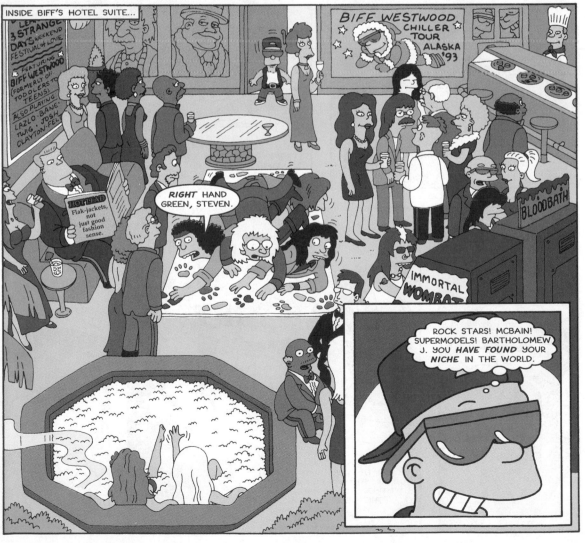

INSIDE BIFF'S HOTEL SUITE...

3 STRANGE DAYS WEEKEND FESTIVAL OF LOVE — FEATURING BIFF WESTWOOD (FORMERLY OF TODDLERS TO TEENS) ALSO PLAYING LAZLO BANE · TWIG · JOSH CLAYTON-FELT

BIFF WESTWOOD CHILLER TOUR ALASKA '93

HOTHEAD — Flak-jackets, not just good fashion sense.

RIGHT HAND GREEN, STEVEN.

BLOODBATH

IMMORTAL WOMBAT

ROCK STARS! MCBAIN! SUPERMODELS! BARTHOLOMEW J. YOU *HAVE FOUND* YOUR *NICHE* IN THE WORLD.

BIFF, WE WERE STARTING TO WORRY ABOUT YOU. YOU REMEMBER RAINIER?

WHO CAN *FORGET* THE STAR OF "FISTFUL OF ARTERIES."

THANK YOU FOR LETTING ME TAG ALONG ON YOUR TOUR. IT WILL BE VALUABLE RESEARCH FOR MY UPCOMING FILM "DEATH, THUGS AND ROCK AND ROLL."

ANYTIME, RAINIER. WE *HIGH PROFILE* CELEBS HAVE TO STICK TOGETHER.

HEY, BIFFSTER, YOU PROMISED ME A REMATCH AFTER THAT *DRUBBING* YOU GAVE ME AT RED ROCKS.

CHESS

YOU'LL HAVE TO WAIT YOUR TURN. BIFF'S PROMISED TO SPEND SOME TIME WITH ME AND SVETLANA.

SORRY, DUDE. IT LOOKS LIKE *I* JUST GOT A DOUBLE WORD SCORE AND THAT WORD IS *BABE!*

POTATO CHIPS

COLA COLA COLA

I JUST BOOKED YOU ON THE KBBL "RAPPIN' 'BOUT ROCK" SHOW, THEN AN INTERVIEW WITH KENT BROCKMAN, AND LATER THE KRUSTY SPECIAL. SO TRY AND GET SOME REST TONIGHT.

MEDIA CIRCUS, HERE I COME.

THE NEXT MORNING...

CLANK!

OH MY, WHAT WAS THAT!

HOMEY, *WAKE UP!* I THOUGHT I *HEARD* SOMETHING.

DID IT SOUND AS IF MILLIONS OF VOICES CRIED OUT IN TERROR AND WERE SUDDENLY SILENCED?

NO, IT CAME FROM THE KITCHEN. AND I SMELL SOMETHING *BURNING!*

YAAAAGH! SOMEONE'S COOKING MEAT WITHOUT ME!!

BART, WHAT ARE YOU DOING?

I'M SORRY. I DROPPED A PAN WHILE MAKING BREAKFAST.

I SUPPOSE BART NEVER COOKS, BUT I HAD TO MAKE SURE MY BREAKFAST WAS MADE WITH SOY-MILK AND EGG SUBSTITUTES FOR A HEALTHIER START TO THE DAY.

BOY, IF THESE PANCAKES *TASTE* HALF AS GOOD AS THEY LOOK, THEN THEY *LOOK* TWICE AS GOOD AS THEY TASTE.

LISTEN, BART. I DIDN'T TELL MOM THAT YOU SNUCK OUT OF THE HOUSE, BUT MAKING BREAKFAST IS AN OBVIOUS SIGN THAT YOU'RE UP TO SOMETHING. SHE'S SURE TO GET SUSPICIOUS.

THIS OMELETTE IS DELICIOUS, BART. IT LOOKS LIKE MY SPECIAL GUY IS *GROWING UP.*

...OR NOT.

LATER...

THIS MUST BE MILHOUSE.

BART, MY FRIEND, YOUR WORRIES ARE OVER.

I HOLD IN MY HAND THE *ULTIMATE* CHEAT SHEET FOR MS. KRABAPPEL'S TEST.

NO NEED, MILHOUSE, IT'S ALL UP HERE.

WELL, O.K., BART, BUT IF YOU GET IN TROUBLE JUST SHOOT THIS RUBBER BAND AT MARTIN.

HIS BLUBBERING WILL CREATE A DIVERSION DURING WHICH I CAN PASS YOU THE CRIB NOTES.

BART'S LUCKY. THIS GUY'S A *TRUE* FRIEND. *ETHICALLY BANKRUPT*, BUT A TRUE FRIEND.

INSIDE THE CLASSROOM...

ALL RIGHT, CLASS. GET OUT YOUR PENCILS, IT'S TIME FOR THE HISTORY TEST.

AS USUAL, I HAVE TAKEN THE LIBERTY OF MAKING ONE *MINOR* SEATING ADJUSTMENT. BART, YOU WILL BE SITTING THERE.

I'D LIKE TO THINK SHE HAS BART SIT HERE SO THE OTHERS WON'T CHEAT OFF OF *HIM*.

WHEN YOU'RE FINISHED PLEASE RAISE YOUR HAND AND I'LL COME BY AND COLLECT YOUR PAPERS.

A FEW MINUTES LATER...

BART, YOU SHOULD HAVE GONE TO THE LAVATORY *BEFORE* CLASS.

NO, I'M READY TO HAND IN MY TEST.

GIVING UP SO SOON? HONESTLY, BART, COULDN'T YOU AT LEAST *PRETEND* TO FINISH THE TEST?

TOMMOROW'S LESSON: PGS. 231-240 QUESTIONS 5-44

BUT I HAVE FINISHED. I'VE ANSWERED *ALL* THE QUESTIONS. *THAT'S* WHY I'M HANDING IT IN.

BOY, BART'S REALLY SET SOME LOW EXPECTATIONS FOR HIMSELF AROUND HERE.

THIS ISN'T POSSIBLE! BART'S FINISHED AND I'M ONLY HALF WAY THROUGH THE ESSAY QUESTION ON THE TREATY OF BREST-LITOVSK, WHICH WHILE NOT AS COMMONLY KNOWN AS THE TREATY OF VERSAILLES, IS STILL QUITE A RIPPING TALE.

THAT'S ENOUGH, MARTIN, THANK YOU. BART, I'LL TAKE YOUR TEST--THE REST OF YOU GET BACK TO WORK.

"NUCLEAR BLUES"
THE TOXICS

KDFL RADIO

THAT WAS ANOTHER *TWO* SONGS IN A ROW, COMMERCIAL FREE.

NOW, I'D LIKE TO INTRODUCE MY IN-STUDIO GUEST, PRE-TEEN SINGING SENSATION, BIFF WESTWOOD.

THANKS. I'D LIKE TO TAKE THIS OPPORTUNITY TO LET ALL MY FANS IN SPRINGFIELD KNOW THAT WE, THE *POP MUSIC ELITE,* AGREE THAT "SPRINGFIELD ROCKS AND ALWAYS WILL, WHILE SHELBYVILLE SU--"

"-CKS AND ALWAYS WILL."

I LOVE IT WHEN ROCK DUDES TAKE A *POLITICAL STAND.*

BART, I DON'T KNOW WHAT YOU'RE UP TO, BUT I'M CERTAIN IT WILL BRING SHAME TO OUR ALREADY *BESMIRCHED* FAMILY NAME.

NO NEED TO CONCERN YOURSELF, SIS. I PROMISE I'VE TURNED OVER A NEW LEAF.

I'D SAY BY YOUR NEW STUDY HABITS THAT IT SEEMS YOU'VE TURNED OVER A NEW *LOOSE-LEAF.*

AND ALTHOUGH I AM STILL PAINED BY THE HUMILIATION OF BEING OUTDONE BY YOU TODAY IN CLASS, I AM STILL ABLE TO COME UP WITH A TIMELY SCHOLASTIC PUN TO SOOTHE MY WOUNDS.

C'MON, LISA, FIRST ONE HOME GETS TO HELP MOM FOLD LAUNDRY!

NOW MY CONCERN IS SHIFTING TO HIS *MENTAL HEALTH.*

STOP WHEN RED LIGHTS

SPRING

YOU'VE ONLY INTENSIFIED MY DESIRE TO EXCEL! FOR THAT I AM ETERNALLY GRATEFUL.

LATER THAT NIGHT...

THANK YOU SO MUCH FOR HELPING ME WITH THE DISHES AND FOR MAKING THAT DELICIOUS DESSERT, BART.

MY PLEASURE. THERE'S SOMETHING VERY *ZEN* ABOUT DOING DISHES.

MMM... CREME BRULEE!

SINCE BART HAS BEEN SUCH A GREAT HELPER, WHY DON'T WE LET HIM DECIDE WHAT WE WATCH TONIGHT?

BUT, MOM, I WAS GOING TO WATCH *BIFF WESTWOOD* ON KENT BROCKMAN'S CELEBRITY SPOTLIGHT. BART'S NOT GOING TO WANT TO WATCH THAT.

WHY NOT? I THINK HE'S PRETTY COOL.

NOW I CAN SEE BART FILL *MY* SHOES.

BUT, BART THINKS BIFF WESTWOOD IS A "NO-TALENT PREFAB PRETTY BOY."* SOMETHING *FUNNY`S* GOING ON.

* SEE SIMPSONS ILLUSTRATED, SUMMER 1993 ~ ED.

Z Z Z Z Z Z

I'LL GET THAT.

RING-A-RING!

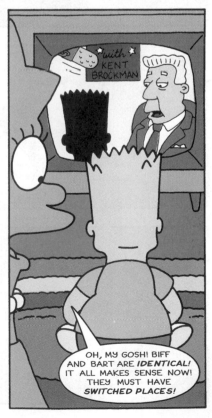

with KENT BROCKMAN

OH, MY GOSH! BIFF AND BART ARE *IDENTICAL!* IT ALL MAKES SENSE NOW! THEY MUST HAVE *SWITCHED PLACES!*

OUR SPOTLIGHT TONIGHT IS ON A YOUNG PERFORMER THAT MY KIDS JUST LOVE. AT LEAST THAT'S WHAT MY EX-WIFE SAYS, AND AFTER ALL, SHE SHOULD KNOW--SHE WON THE CUSTODY BATTLE.

CELEBRITY REPORT with KENT BROCKMAN

43

YOU'RE *BIFF WESTWOOD*, AREN'T YOU!?! I'VE ALWAYS *DREAMED* OF MEETING YOU, BUT IN THE *DEEPEST* RECESSES OF MY FERTILE IMAGINATION I NEVER THOUGHT IT WOULD HAPPEN LIKE THIS.

AND I'VE DREAMED OF MEETING SOMEONE LIKE *YOU*. I'VE ALWAYS WANTED A SISTER TO LOOK AFTER AND WHO'LL LOOK AFTER ME.

YOU HAVE?

I'M JUST SAD THAT IT ALL HAS TO END TOMORROW NIGHT BEFORE KRUSTY'S LIVE SHOW WHEN BART AND I SWITCH BACK.

BUT KRUSTY'S ANNIVERSARY SHOWS ARE NEVER *REALLY* LIVE, HE JUST SAYS THAT TO GET BETTER RATINGS! THE TAPING IS *TONIGHT*.

IT IS? *OY, LA BAMBA!* WE'VE GOT TO FIND BART *RIGHT AWAY!*

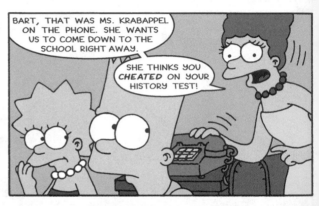

BART, THAT WAS MS. KRABAPPEL ON THE PHONE. SHE WANTS US TO COME DOWN TO THE SCHOOL RIGHT AWAY.

SHE THINKS YOU *CHEATED* ON YOUR HISTORY TEST!

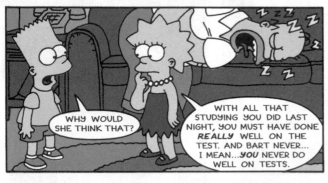

WHY WOULD SHE THINK THAT?

WITH ALL THAT STUDYING YOU DID LAST NIGHT, YOU MUST HAVE DONE *REALLY* WELL ON THE TEST. AND BART NEVER... I MEAN...*YOU* NEVER DO WELL ON TESTS.

THIS PREDICAMENT IS MY RESPONSIBILITY. FIRST WE'LL TALK TO MS. KRABAPPEL, THEN WE'LL FIND BART.

COME ON, KIDS. I WON'T HAVE BART'S INTEGRITY QUESTIONED BY ANYONE BUT ME. LET'S GO!

...I'LL TELL YOU KENT, IT'S NOT HARD TO FIND YOUR MUSE WHEN YOU'RE KNEE DEEP IN HUNDRED DOLLAR BILLS.

AS YOU CAN SEE, BART'S GRADES HAVE ALWAYS BEEN IN THIS AREA--

EXCUSE ME PRINCIPAL SKINNER, THAT'S THE WRONG CHART.

NUTRITIONAL VALUE OF SCHOOL LUNCHES

EXCEPTIONAL
VERY GOOD
GOOD
INADEQUATE
POOR
TOXIC

LOOK, MRS. SIMPSON, I DON'T NEED GRAPHS AND CHARTS TO REMIND YOU THAT YOUR SON IS, AND ALWAYS WILL BE, AN *UNDERACHIEVER.*

NOW YOU LISTEN HERE, PRINCIPAL SKINNER. BART MAY NOT HAVE ALWAYS BEEN A MODEL STUDENT, BUT PEOPLE CHANGE.

THE BART I'VE KNOWN THESE PAST 24 HOURS IS A *HARD-WORKING* STUDENT WITH *EXCELLENT* STUDY HABITS AND A TALENT FOR MAKING *DELICIOUS* FOREIGN DESSERTS.

I WOULD CONSIDER ACCEPTING THIS INSTANT *TRANSFORMATION* IF BART SUCCESSFULLY ANSWERS A FEW IMPROMPTU HISTORY QUESTIONS.

I SEE NO REASON WHY MY BROTHER SHOULD BE SUBJECTED TO A CROSS EXAMINATION WHEN HE'S ALREADY PROVED--

I DON'T MIND. GO AHEAD, FIRE AWAY.

LATER...

...THEN, IN MAY OF 1915, ITALY DECLARED WAR ON AUSTRIA, ENDING THE TRIPLE ALLIANCE WHICH HAD BEEN FORMED 33 YEARS EARLIER WITH--

YES, YES, THAT WILL DO.

I HOPE YOU'LL REMEMBER THIS THE NEXT TIME EITHER OF YOU DOUBT THE ABILITY OF CHILDREN TO BETTER THEMSELVES.

45

MEANWHILE...

...AND MAKE SURE YOU CATCH MY CAMEO ON THE NEW HIT SERIES, "SPRINGFIELD SHORES."

I PLAY A BLOATED CORPSE THAT WASHES UP ON THE BEACH RIGHT IN THE MIDDLE OF THE COPPERTONE BIKINI NATIONALS!

EVEN FROM BACKSTAGE, I CAN *FEEL* HIS POWER AS AN ENTERTAINER.

★ BIFF ★ WESTWOOD

KRUSTY THE CLOWN

STAY TUNED! WE'LL BE RIGHT BACK WITH BIFF WESTWOOD AND THE ORIGINAL "BENJI," WHO FOR LEGAL REASONS MUST WORK UNDER THE NAME, "BENNY."

GOOD LUCK, KID. IT'S A TOUGH CROWD. THE FIRST THREE ROWS ARE ALL INDUSTRY PEOPLE. YOU'D THINK IT'D KILL 'EM TO CRACK A SMILE. YEESH!

DON'T WORRY, KRUSTY, IF ANYBODY CAN WIN THIS CROWD OVER, *BIFF WESTWOOD* CAN.

NOW, IF ONLY *BIFF WESTWOOD* WERE HERE INSTEAD OF ME. I'D BETTER TRY TO CALL HIM ONE MORE TIME.

IF YOU'LL EXCUSE ME, I NEED TO DO SOME...UH...*VOCAL* WARM-UPS.

HEH – HEH... TECHNOLOGY, WHAT WILL THEY THINK OF NEXT?

BART!! IT'S *YOU* CALLING.

IN A MOMENT...

HELLO?

BART, PLEASE... TELL HIM IT'S BART.

IN FRONT OF THE SIMPSON HOUSE...

OTTO EXPRESS AT YOUR SERVICE! WHOA, ARE YOU SURE THIS ISN'T BART?

SCHOOL BUS

I'M SURE, OTTO. THANKS FOR HELPING BIFF AND ME GET TO THE KRUSTY SHOW.

ANYTHING TO HELP OUT A *FELLOW ARTISTE* AND CATCH A *FREE* GIG.

THE SIMPSONS

INGFIELD DITORIUM

BIFF IN PERSON D WESTWOOD

STAGE DOOR

SHELBYVILLE DEMANDS AN APOLOGY

WESTWOOD *NOT* WELCOME IN SHELBYVILLE

SHELBYVILLE Doesn't Suck!!!

SORRY, KIDS. NO ONE GETS IN WITHOUT A PASS.

NOW IT'S TIME TO IMPLEMENT BART'S PLAN "D."

OH, LOOKS LIKE YOU HAVE ONE OF THE *NEW PASSES*... YEAH... THIS'LL DO JUST FINE. GO ON IN.

OH, NO! HE'S ALREADY ON STAGE! WE'RE *TOO LATE!*

THIS IS WHERE MY YEARS AS A *ROADIE* FOR MILLI VANILLI PAY OFF.

WHAT'LL WE DO?

WHERE ARE THEY?

ALL RIGHT... LET'S GET THIS SHOW ON THE ROAD.

HELLO, SPRINGFIELD! ARE YOU READY TO ROCK?

O.K., DUDES, NOW!

ONSTAGE MIC — OFF / ON

BACKSTAGE MIC — OFF / ON

CLICK!

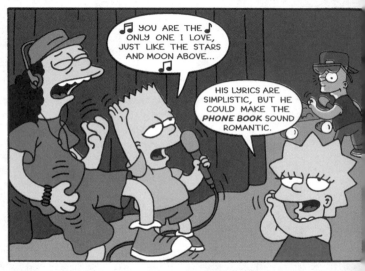

♪ YOU ARE THE ONLY ONE I LOVE, JUST LIKE THE STARS AND MOON ABOVE... ♪

HIS LYRICS ARE SIMPLISTIC, BUT HE COULD MAKE THE *PHONE BOOK* SOUND ROMANTIC.

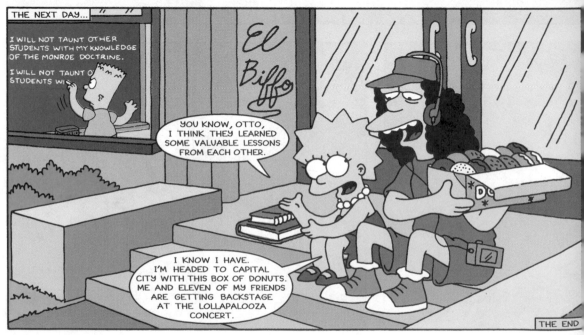

THE NEXT DAY...

I WILL NOT TAUNT OTHER STUDENTS WITH MY KNOWLEDGE OF THE MONROE DOCTRINE.

I WILL NOT TAUNT O[THER] STUDENTS WI[TH]

El Biffo

YOU KNOW, OTTO, I THINK THEY LEARNED SOME VALUABLE LESSONS FROM EACH OTHER.

I KNOW I HAVE. I'M HEADED TO CAPITAL CITY WITH THIS BOX OF DONUTS. ME AND ELEVEN OF MY FRIENDS ARE GETTING BACKSTAGE AT THE LOLLAPALOOZA CONCERT.

THE END

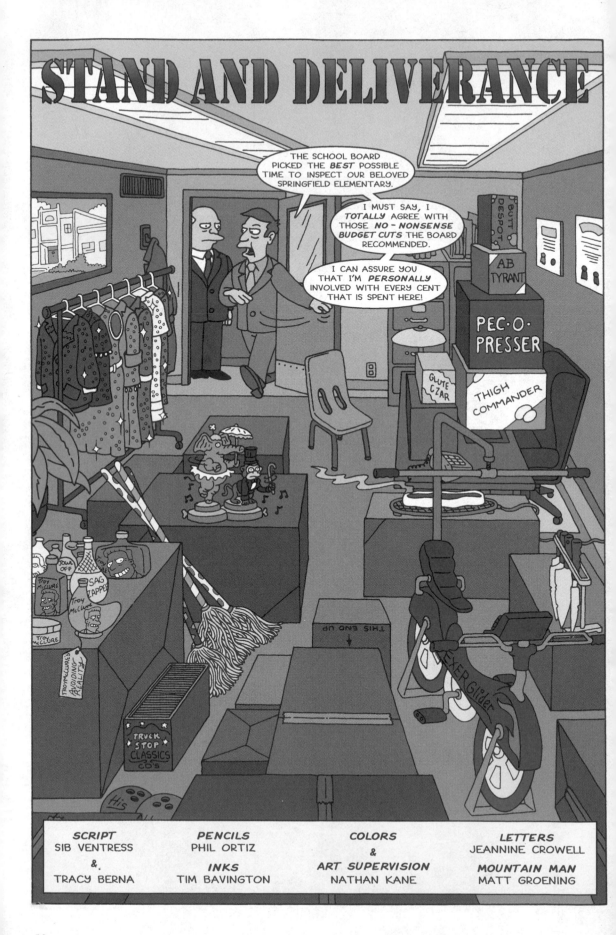

STAND AND DELIVERANCE

THE SCHOOL BOARD PICKED THE *BEST* POSSIBLE TIME TO INSPECT OUR BELOVED SPRINGFIELD ELEMENTARY.

I MUST SAY, I *TOTALLY* AGREE WITH THOSE *NO - NONSENSE BUDGET CUTS* THE BOARD RECOMMENDED.

I CAN ASSURE YOU THAT I'M *PERSONALLY* INVOLVED WITH EVERY CENT THAT IS SPENT HERE!

SCRIPT	PENCILS	COLORS	LETTERS
SIB VENTRESS	PHIL ORTIZ	&	JEANNINE CROWELL
&		ART SUPERVISION	
TRACY BERNA	INKS	NATHAN KANE	MOUNTAIN MAN
	TIM BAVINGTON		MATT GROENING

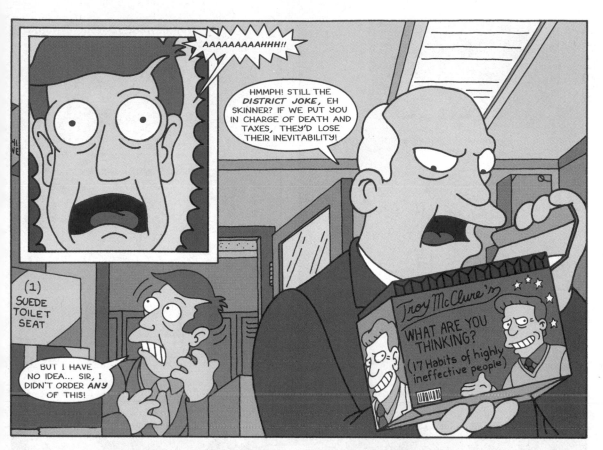

AAAAAAAAAHHH!!

HMMPH! STILL THE **DISTRICT JOKE**, EH SKINNER? IF WE PUT YOU IN CHARGE OF DEATH AND TAXES, THEY'D LOSE THEIR INEVITABILITY!

(1) SUEDE TOILET SEAT

BUT I HAVE NO IDEA... SIR, I DIDN'T ORDER **ANY** OF THIS!

Troy McClure's

WHAT ARE YOU THINKING?
(17 Habits of highly ineffective people)

SIR...WAIT! UM, UH, ACCORDING TO COLLECTORS, THIS PLATE IS... UH, **GUARANTEED** TO QUADRUPLE IN VALUE OVER THE NEXT 10 YEARS!

SWOOOSH!

IT'S AN INVESTMENT!!!

HAVE A NICE TIME TAKING UP SPACE WHILE YOU CAN, SKINNER.

YANK!

WITH GOD AS MY WITNESS...

...I'LL NEVER BE *HUMILIATED* LIKE THIS AGAIN!

SALAD UZI!

KRUSTY KROONS THE KLASSICS

SHEEA PET

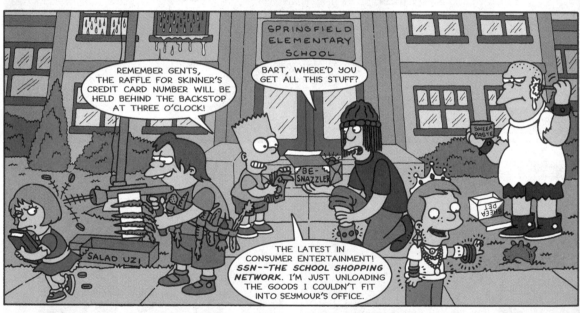

REMEMBER GENTS, THE RAFFLE FOR SKINNER'S CREDIT CARD NUMBER WILL BE HELD BEHIND THE BACKSTOP AT THREE O'CLOCK!

BART, WHERE'D YOU GET ALL THIS STUFF?

THE LATEST IN CONSUMER ENTERTAINMENT! *SSN--THE SCHOOL SHOPPING NETWORK.* I'M JUST UNLOADING THE GOODS I COULDN'T FIT INTO SEYMOUR'S OFFICE.

SPRINGFIELD ELEMENTARY SCHOOL

SALAD UZI

BE-SNAZZLER

SHEEA PASTE

SHEEA PET

AND YET, I'M SURE WE CAN FIND SPACE FOR YOU, YOUNG COMMERCE *ABUSER!*

PLINK!

YOU'VE GOT *NOTHING* ON ME, MAN. I DIDN'T *DO* IT. NO ONE *SAW* ME DO IT. YOU CAN'T *PROVE* ANYTHING.

AU *CONTRAIRE!* YOUNG MILHOUSE *SANG* LIKE A WELL-FED CANARY!

ACK!

KRUSTY KROONS THE KLASSICS

INEVITABLY...

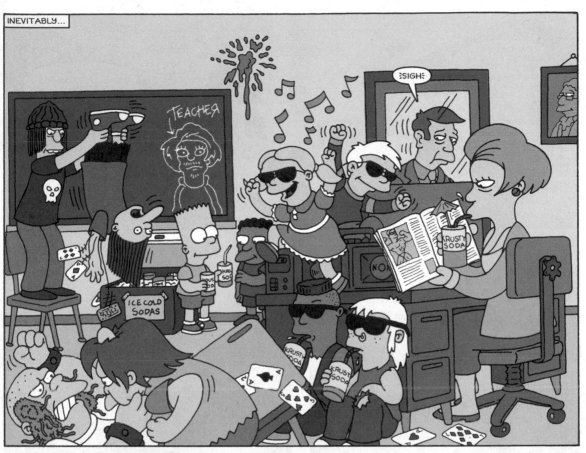

:SIGH:

TEACHER

NO...

ICE COLD SODAS

KRUSTY SODA

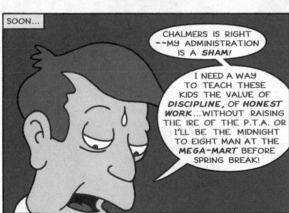

SOON...

CHALMERS IS RIGHT --MY ADMINISTRATION IS A *SHAM!*

I NEED A WAY TO TEACH THESE KIDS THE VALUE OF *DISCIPLINE,* OF *HONEST WORK*...WITHOUT RAISING THE IRE OF THE P.T.A. OR I'LL BE THE MIDNIGHT TO EIGHT MAN AT THE *MEGA-MART* BEFORE SPRING BREAK!

I'VE GOT AN IDEA... A *BRILLIANT* IDEA!

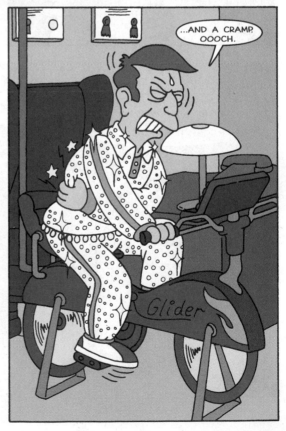

...AND A CRAMP. OOOCH.

Glider

NEXT DAY...

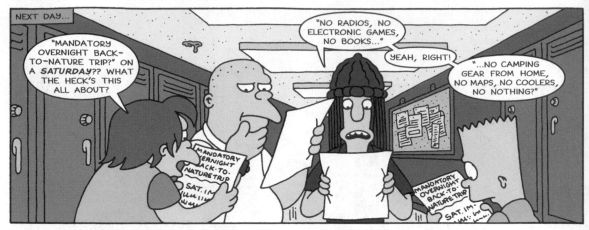

"MANDATORY OVERNIGHT BACK-TO-NATURE TRIP?" ON A *SATURDAY*?? WHAT THE HECK'S THIS ALL ABOUT?

"NO RADIOS, NO ELECTRONIC GAMES, NO BOOKS..."

YEAH, RIGHT!

"...NO CAMPING GEAR FROM HOME, NO MAPS, NO COOLERS, NO NOTHING?"

"RECENT DEVELOPMENTS HAVE MADE IT NECESSARY TO UNDERTAKE *ALTERNATIVE DISCIPLINARY MEASURES*. ANY STUDENT WHO HAS BEEN GIVEN *DETENTION* MORE THAN *TWENTY TIMES* THIS MONTH IS HEREBY *REQUIRED* TO ACCOMPANY SCHOOL OFFICIALS ON A *BACK-TO-BASICS* CAMPING TRIP."

HEY GEEK, STOP READING OVER MY SHOULDER!

I'M NOT, *I* GOT ONE TOO!

PRINCIPAL SKINNER, CERTAINLY THERE'S BEEN A *MISTAKE* IN MY RECEIVING THIS NOTICE! THIS IS *EGREGIOUS*!

UH, NO MARTIN... THERE'S *NO MISTAKE*... AND WHAT HAVE I TOLD YOU ABOUT USING WORDS I DON'T UNDERSTAND?

THE SCHOOL'S *STATE-OF-THE-ART* COMPUTER MADE THESE DETERMINATIONS, AND COMPUTERS DON'T LIE!

WHUDAWHUDAWHUDAWHUDAWHUDA!

THAT SATURDAY...

MOOOOM! I CAN'T WEAR THIS *SISSY* THING!

I THINK IT'S CUTE! BESIDES, YOU HAVEN'T WORN THIS EVEN *ONCE* SINCE YOUR AUNTS BOUGHT IT FOR YOU.

HEY, BART-- COOL SWEATSHIRT! WE'RE *"TWINNERS,"* AS THE COLLOQUIALISM GOES!

SAY THERE, SOON-TO-BE-HE-MEN... WHERE ARE YOUR FELLOW *NE'ER-DO-WELLS*?

WHY, I DON'T KNOW WHERE THE *OTHERS* ARE, SIR, BUT I'M CERTAIN THEIR EXCUSE MUST BE A VERY *GOOD* ONE. WHO WOULD DARE DEFY YOUR FIRM BUT *CON-SIDERATE* GUIDANCE?

BOYS, LOOK WHO DECIDED TO JOIN US! WHO MORE *APPROPRIATE* TO COME ALONG ON THIS *MEN-ONLY* ADVENTURE?

CLIMB ABOARD, LITTLE DUDES!

ACH! IF M' CONTRACT DIDN'NA DEMAND THAT I SUPERVISE THE USE O' SCHOOL EQUIPMENT ON AND OFF CAMPUS...

...I'D BE FEEDIN' YER *GIZZARD* T'A FLOCK O' *RABID WOODPECKERS* FOR EVEN SUGGESTIN' THIS TRIP!

BEHOLD, DUDES! MY MASTERPIECE! THE *STAR-SPANGLED WEDGIE!*

LATER, ON THE ROAD...

WHHHOOAA!

SPRINGFIELD ELEMENTARY SCHOOL

STOP WHEN RED LIGHTS FLASH

SCREEE!

BELCH!

SIZZLE! CRACKLE! SIZZLE!

COUGH! WHEEZ!

WHEW! THAT WAS CLOSE! I WOULDN'T WANNA UPSET THE *BALANCE OF NATURE!*

SCHOOL BUS

YOU KNOW, WHEN WE GET WHERE WE'RE GOING, YOU BOYS HAD BETTER KEEP YOUR EYES PEELED --SOME PRETTY *STRANGE THINGS* CAN COME OUT OF THE WOODS, SOME PRETTY *STRANGE PEOPLE*, TOO... WHICH REMINDS ME OF A STORY. YOU SEE, NOT EVERY SPRINGFIELD ELEMENTARY FIELD TRIP HAS TURNED OUT *HAPPILY*.

THAT'S RIGHT! THE *BALL BEARING FACTORY* STILL HASN'T REOPENED!

HEH! HEH! HEH!

KNOW WHERE YOU STAND. GET YOUR BEARINGS! --MANAGEMENT

MASTER CONTROL

OVER RIDE

WHAT DID THAT KID *DO*?

BALL BEARINGS

WE HAVE BEEN *FORSAKEN!!!*

WELL, THAT EXPLAINS THIS *VOLUMINOUS* PARENTAL RELEASE FORM...

NO SIR, WE HAVEN'T.

HAVE YOU BOYS HEARD THE *HORRIBLE* STORY OF THADDEUS JACKSON?

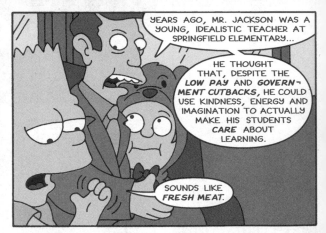

YEARS AGO, MR. JACKSON WAS A YOUNG, IDEALISTIC TEACHER AT SPRINGFIELD ELEMENTARY...

HE THOUGHT THAT, DESPITE THE *LOW PAY* AND *GOVERN-MENT CUTBACKS*, HE COULD USE KINDNESS, ENERGY AND IMAGINATION TO ACTUALLY MAKE HIS STUDENTS *CARE* ABOUT LEARNING.

SOUNDS LIKE *FRESH MEAT*.

HE TOOK PITY ON SOME *YOUNG MISCREANTS* LIKE YOU, SIMPSON, AND DECIDED THAT SOME *EXTRA ATTENTION* MIGHT BE JUST THE THING THEY NEEDED. SO HE ENDEAVORED TO TAKE THEM ON A *FIELD TRIP* MUCH LIKE OURS, TO CATALOG THE LOCAL FLORA AND FAUNA...

SPRINGFIELD ELEMENTARY SCHOOL

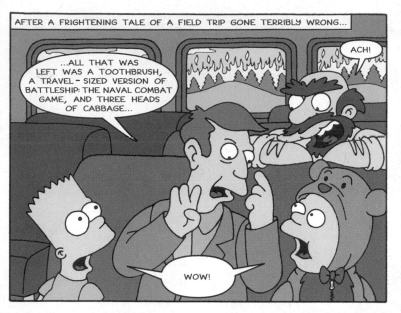

AFTER A FRIGHTENING TALE OF A FIELD TRIP GONE TERRIBLY WRONG...

...ALL THAT WAS LEFT WAS A TOOTHBRUSH, A TRAVEL-SIZED VERSION OF BATTLESHIP: THE NAVAL COMBAT GAME, AND THREE HEADS OF CABBAGE...

ACH!

WOW!

SOME SAY HE SNAPPED FROM THE EXPERIENCE, AND VOWED REVENGE AGAINST THOSE WHO TORMENTED HIM--*REVENGE AGAINST ALL DELINQUENTS!*

A FEW CAMPERS HAVE SEEN HIM, AN AWFUL SLIME CREATURE ROAMING THE WOODS... WHO KNOWS WHAT HE'D DO IF HE EVER *CAUGHT* SOMEONE?

MEANWHILE...

SPRINGFIELD DEPT. OF PARKS

FLIGHT 27 TO TOWER, COME IN, TOWER! *BRUSH FIRE* IN SECTOR FIVE-- I'M ON IT!

≶SIGH!≷ THIS VACATION IS *JUST* WHAT THE DOCTOR ORDERED...

A FEW MORE WEEKS OF THIS AND I MIGHT JUST TELL THAT *HALF-BAKED HARLEQUIN BOSS* OF MINE TO KISS MY PATOOT!

WHAT THE...?!

AT THE CAMPSITE...

EEEYAAGH!!!

SPRINGFIELD ELEMENTARY SCHOOL

WELL WILLIE, I TRUST THAT THESE BOYS ARE IN GOOD HANDS!

DO YOUR BEST TO TURN THEM INTO *GOOD, OBEDIENT FOOT SOLDIERS* AND I'LL SEE YOU ALL IN A *COUPLE OF DAYS*.

DOON'T TELL ME YOU'RE *NOT STAYIN'*??!

OF COURSE I'M NOT STAYING, WILLIE! I'VE RESERVED THIS WEEK- END FOR MY *MONTHLY CLEANSING RITUAL!*

ABANDONIN' YER DUTIES TA GO CLEAN HOUSE?

GOIN' HOME TA TIDY UP YER *FLUFFY PINK BOUDOIR*??

WILLIE, MY RITUAL INVOLVES THREE DAYS OF FASTING IN TOTAL ISOLATION.

THEN, LYING ON A ROCK AT NATURE'S MERCY AND WEARING NOTHING BUT A LOINCLOTH, I ATTEMPT TO SWEAT OUT THE DEMONS THAT CLOUD MY SOUL!

WELL, WHY DINNA YA *SAY* SO? THAT'S THE FIRST BIT O' *SENSE* I'VE EVER HEARD FROM YE, MAN. IN FACT, YE JUST DESCRIBED ME LAST *SUMMER VACATION!*

GIVE 'EM HELL, TROOPS!

SAY 'ALLO T'YOUR *DEMONS* FER ME!

EMENTARY OL

STOP WHEN RED LIGHTS FLASH

GET BENT.

LATER...

I'M *STARVING*, MAN! WHAT'S TO EAT?

PROPERTY OF CONFEDERATE ARMY

WHATEVER 'TIS, NO DOUBT YOU'D LIKE IT ALL SERVED T' YE ON A TRAY WITH A *ROSE* AND A *WEE LACE DOILY*!

GOULASH IN A BAG. I'M *REPELLED*, YET *STRANGELY ATTRACTED*.

THIS STROGANOFF IS *GLOWING*.

ACH! TIME FOR A *HUNTIN'* LESSON.

HUNGARIAN INSTA-MEALS FOR HUNGRY HUNTERS

SOON...

NOW YOU BOYS ARE GON' TA LEARN HOW A REAL MAN CATCHES A MEAL--WITH HIS *OWN* TWO HANDS!

HUCK FINN SPECIAL. 3-INCH PARITY. ELASTI-BANDS WITH WOOL BLEND POUCH... IT'LL DO.

FINALLY! IT IS *I* WHO WILL BE THE HUNTER AND *ANOTHER* THE PREY!

AH HA!

AWWWW... MAN, *SCHOOL WINDOWS* NEVER HAVE EYES LIKE *THAT*!

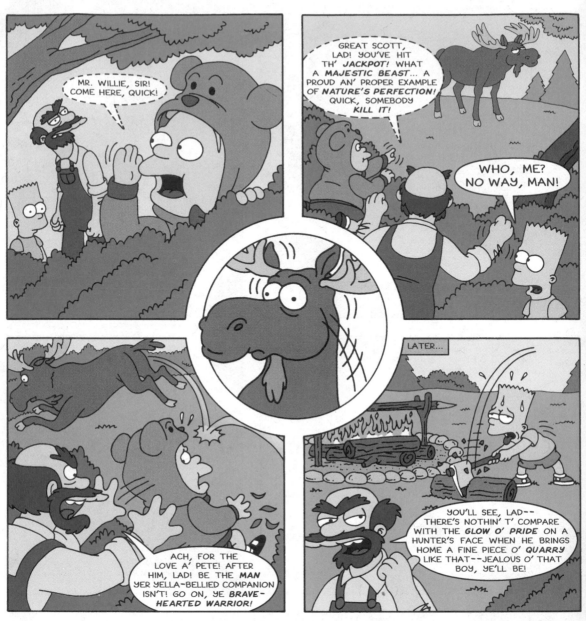

NIGHT FALLS...

STILL SOME SMOLDERING IN SECTOR 9...

...COMMENCING EMERGENCY SATURATION.

SPLOOOSH!

HHOOOOWAAAA!

BLEAH! COFF! COFF!

...HUH?

NEARBY...

CHATTER CHATTER

...ZZZZZZ...

...OOHHHH...

PROPERTY OF CONFEDERATE ARMY

PROPERTY OF CONFEDERATE ARMY

PROPERTY OF CONFEDERATE ARMY

...OOHHHH... THAT FREEZE-DRIED NOODLE KUGEL WAS NOT OF THIS EARTH...

BY KRUSTY... WHAT IS *THAT?*

RUSTLE!
RUSTLE!

UHHHHHNNNNHH...

¡GASP!¡ FROZEN... WITH...FEAR...PSYCHO TEACHER...SKINNER... TOLD...TRUTH!

N-N-N-N-NO *DELINQUENTS* IN HERE, MAN... YOU WANT THE NEXT TENT OVER!

...UHHHNNNUUHNNNN...

CHATTER!
CHATTER!
CHATTER!

IT'S THADDEUS JACKSON! YEEEEK!

YEAAAAGH!

BLEAA-HA-HA-HA-HA-HA-HHHAAA!

HELP, HELP... PANT, PANT!...

CRAZED EDUCATOR... *HELP!*...WHAT'S THAT UP AHEAD? A CABIN!

SANCTUARY! SANCTUARY! EH? WHAT'S THIS?

MMMM!...YANKEE BEAN SOUP WITH PORK ANKLES... THAT LUNCH LADY DORIS IS AN *ARTIST* WITH FOOD! I CAN'T UNDERSTAND WHY WE ALWAYS HAVE *SO MUCH* OF THIS LEFT OVER...

SPRINGFIELD ELEMENTARY FOOD SERVICE

MILK

PROPERTY OF SPRINGFIELD ELEMENTARY A.V. DEPT.

ZOUNDS! WHAT FOUL TREACHERY IS THIS? AND ISN'T THAT *LAST FRIDAY'S SOUP?*

ONE TALE OF A WEASELLY PRINCIPAL LATER...

OH YES! IT WAS PRINCIPAL SKINNER, ALL RIGHT!

THAT NO-GOOD, WEB-SPINNIN', FERRET-FACED HEAP O' DONKEY DROPPIN'S!

I'LL GIVE THAT SILK-WEARIN' NANCY BOY SKINNER A *DRUBBIN'* HE'LL NOT SOON FORGET!

SAVE A PIECE FOR ME, WILLIE!

AND I AS WELL!

TIS DONE! YE LADS'RE COMIN' WITH ME. BUT FIRST... WE *TRAIN!*

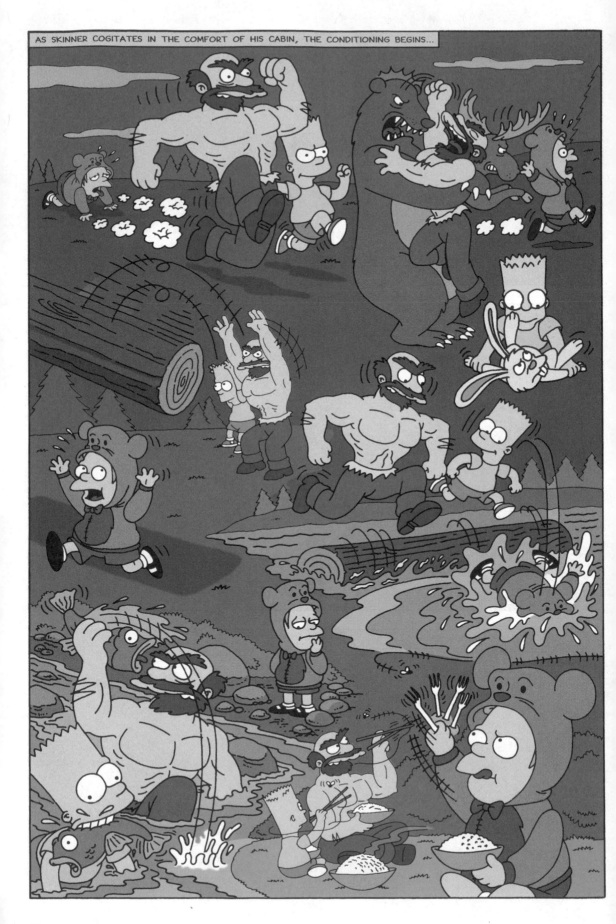

THE TIME DRAWS NIGH, ME WEE *FEARLESS GLADIATORS*. ARE YE READY?

AYE, WILLIE!

YOU TWO GO; THERE'S NO HOPE FOR ME. THIS TRAINING HAS *BROKEN* MY *BODY*, MY *SPIRIT*...AND WORST OF ALL, MY *PEN!* THIS SHIRT IS LINEN-- IT'LL NEVER COME OUT.

ACH! THEN IT'S JUST THE *TWO* OF US! LET'S NA *WASTE* ANOTHER MINUTE. WE'RE OFF!

SHORTLY...

THERE'S THE SCURVY *TRAITOR* NOW...HE'LL NEVER KNOW WHAT *HIT* 'IM!

NOW PUT YER SHIRT BACK ON-- YER GIVIN' ME THE CREEPS.

I'LL TAKE TH' *ROOF WATCH*, LAD; Y'KNOW WHAT TO DO 'ROUND BACK!

HMM..."WHITE BLOOD CELLS: THE BODY'S FOOT SOLDIERS" OR "SPONTANEOUS CELL DIVISION IN AMOEBAS"...AM I IN THE MOOD FOR SOMETHING *INSPIRING* OR *RACY*...?

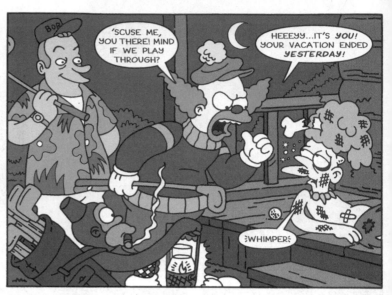

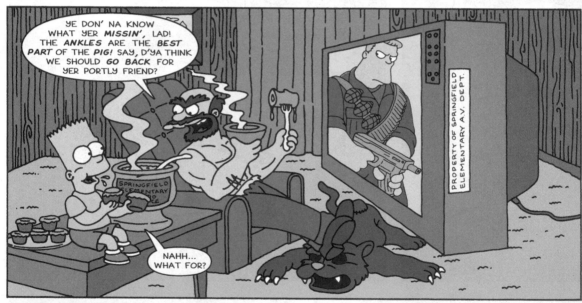

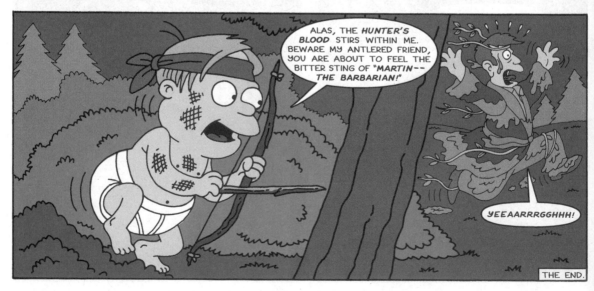

DON'T YOU REALIZE THAT THE JUICE OF THE COW IS *SACRED* REGARDLESS OF IT'S *DATE OF EXPIRATION*?!

POLYSORBATE 90
It's not fresh 'till it's Polysorbate 90 fresh!

NACHOS

MEIN *GOTT--MILK!!!*

YOINK!

UNCLE APU, DUE TO YOUR HIGH LEVEL OF ANXIETY, YOU APPEAR TO HAVE BROKEN RULE NUMBER TWENTY-SEVEN OF THE KWIK-E-MART HANDBOOK: "NEVER SCARE OFF THE *PORTLY CUSTOMERS*--THE *HEAVY-SET* ARE YOUR *BEST BET!*" IS SOMETHING WRONG?

TO SAY THE LEAST! MY MIND IS BUBBLING OVER WITH INSECURITIES, SELF-DOUBT, AND POORLY TIMED UNEMPLOY-MENT CONCERNS.

THE TRUTH IS, I HAVE NOT BEEN THIS UNSURE OF MY STORE'S FUTURE SINCE OLD BUZZ COLA WAS *REPLACED* BY NEW BUZZ COLA BACK IN '85!

EMPLOYEE OF THE DECADE

SQUISHEE

A TERRIFYING TIME IN KWIK-E-MART HISTORY! WHAT IS HAPPENING?

SPRINGFIELD'S VERY OWN MONTGOMERY BURNS HAS ANNOUNCED THAT HIS MULTI-BILLION DOLLAR CONGLOMERATE IS ABOUT TO ACQUIRE THE *ENTIRE KWIK-E-MART FRANCHISE!*

BURNS EARNS ON KWIK-E RETURNS

WHAT HAVE WE DONE TO *ANGER* GANESHA IN SUCH A WAY, UNCLE APU?

DUFF

EH! WHO KNOWS! THE QUESTION IS, WILL MARKETING SPECIALISTS *CHANGE* THE KWIK-E FORMAT TO CATER TO TODAY'S *YOUNGER, COFFEE HOUSE CLIENTELE?*

DO I LOOK LIKE A CAST MEMBER OF A POPULAR *TWENTY-SOMETHING SITCOM* TO YOU?

AS WE BOTH KNOW, I DO NOT. THUS, I FEAR FOR MY CONTINUED EMPLOYMENT.

POOF!

THIS *BAT* HAS SEEN SO MANY CUSTOMERS COME AND GO. WHO CAN I *COUNT* ON FOR *PATRONAGE*, IF AND WHEN THAT WHICH IS GOING BEGINS TO GET TOUGH?

RADIOACTIVE SQUADRON TO BASE--WE'VE INFILTRATED THE REFUELING STATION. PREPARE TO *LAUNCH!*

I'M *SO HUNGRY* I COULD EAT A KWIK-E-DOG WITHOUT *HOLDING MY NOSE!*

PLEASE! SHOW SOME RESPECT FOR MY MEAT AND MEAT BY-PRODUCTS!!

IGNITION! RADIOACTIVE POD REACHING WARP SPEED!

OOPS. SORRY APU. DIDN'T MEAN TO *CHEESE YOU OFF!*

HEH, HEH! UH, *GOOD ONE,* BART!

SPROING!

SPLAT!

NACHOS

I WILL ALLOW IT TO GO THIS TIME, YOUNG SIMPSON. I WILL MERELY *MASK* THE TASTE AND COLOR OF THE *MOLTEN PLASTIC* WITH A FEW ADDITIONAL CHUNKS OF RED HOT CHILI PEPPER!

NOW WHAT KIND OF SQUISHEE CAN I DO YOU FOR TODAY?

MEANWHILE, IN THE OFFICE OF CHARLES MONTGOMERY BURNS...

ARE YOU WATCHING THIS, SMITHERS? WHO IS THAT INDIAN GENTLEMAN BEHIND THE COUNTER?

THE CHEROKEE OR NAVAJO, SIR?

THAT ONE, YOU *INATTENTIVE IGNORAMUS!* THE ONE WHO'S *BRILLIANTLY WATERING DOWN* THE SODA DISPENSER!

NO FREE REFILLS

CLICK!

HIS NAME IS APU NAHASAPEEMAPETILON. HE MANAGES THE *SPRING-FIELD* FRANCHISE!

OF COURSE! NOW THAT YOU MENTION IT, I DO HAVE A *VAGUE RECOLLECTION* OF MEETING HIM ONCE BEFORE.

GOOD EVENING, SHOPKEEP. I REQUIRE ALL OF YOUR *SHREDDED COCONUT.*

NOTE THIS MAN'S *INGENUITY!* THIS IS THE KIND OF *CREATIVITY* THAT SHOULD INSPIRE ALL OF OUR BURNS INDUSTRIES EMPLOYEES!

EXCUSE MY IMPERTINENCE SIR, BUT HE'S ASKING PEOPLE TO BUY *SMOKED AND CURED JIM CARREYS.*

CELEBRITY JERKY FIGURINES

COLLECT THEM ALL!

AVAILABLE IN TURKEY or MEATLESS

HE'S A *CORPORATE GENIUS,* SMITHERS! THE KIND OF LEADER THAT I'M LOOKING FOR IN KWIK-E-MART UPPER MANAGEMENT. BRING THAT MAN TO ME *IMMEDIATELY!*

...AND CALL 911. I THINK I *SHATTERED* MY HAND.

THUD!

LATER...

ЕSIGHЕ...ALL OF MY LIFE I HAVE TAKEN PRIDE IN THE KWIK-E-MART LOGO. NOW I WOULD SOONER *EXPECTORATE* ON IT THAN WEAR IT ON MY VISOR.

APU, MAY I SPEAK TO YOU FOR A MOMENT?

MONTY B. EYES KWIK-E

IF YOU MUST. AS YOU CAN SEE, I AM BUSY MAKING AN ATTRACTIVE DISPLAY OUT OF THE *HARBINGERS* OF MY *DOOM*.

WHICH IS PRECISELY WHY MR. BURNS WOULD LIKE TO MEET WITH YOU IN HIS OFFICE. HE LIKES YOUR *STYLE!*

STYLE IS SOMETHING THAT HAS ALWAYS COME *NATURALLY* TO ME. HOWEVER, IF *GOOD FASHION* SENSE IS MR. BURNS' CONCERN...

...HE MAY BORROW MY STANDARD KWIK-E-ISSUE *POLYESTER PANTS* WITH THE ELASTIC WAISTBAND ANYTIME!

BUT PLEASE TELL HIM THAT I CAN NOT VISIT HIM UNTIL MY SHIFT IS OVER NEXT *THURSDAY*.

THAT'S *EXACTLY* THE KIND OF WORK ETHIC WE EXPECTED! LUCKILY, WE'VE COME PREPARED.

BOYS?

MMMPH!

NO

CLOSED

LATER, AT STATELY BURNS MANOR...

HOW ARE YOU FEELING, MR. NAHASAPEEMAPETILON?

I'M SORRY ABOUT THE UNPLEASANTNESS INVOLVED IN PRYING YOU FROM YOUR POST, BUT I FELT IT WAS MOST *URGENT* THAT I SPEAK WITH YOU.

THE *CHLOROFORM HEADACHE* IS A MOTHER-GRABBER AND I CAN NO LONGER SEE IN COLOR, BUT SURPRISINGLY, MY SINUSES ARE CLEARER THAN THEY HAVE BEEN IN YEARS.

THIS IS THE BEGINNING OF A *SPECTACULAR RELATIONSHIP*, APU. THE TRUTH IS, I SEE A BIT OF MYSELF IN YOU--THRIFTY, EAGER. A YOUNG MONTY BURNS BEFORE HE MADE HIS *FIRST MILLION!*

FUNNY, MOST PEOPLE TELL ME I REMIND THEM OF *ERIC ESTRADA.*

I'M GOING TO MAKE YOU THE *OFFER OF A LIFETIME.* YOUR *GREATEST DREAMS* ARE ABOUT TO BE REALIZED AND ALL YOU HAVE TO DO IS SAY *YES!*

OP SECRET!

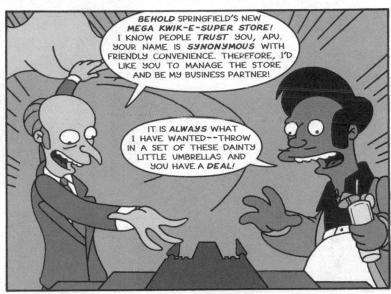

BEHOLD SPRINGFIELD'S NEW *MEGA KWIK-E-SUPER STORE!* I KNOW PEOPLE *TRUST* YOU, APU. YOUR NAME IS *SYNONYMOUS* WITH FRIENDLY CONVENIENCE. THEREFORE, I'D LIKE YOU TO MANAGE THE STORE AND BE MY BUSINESS PARTNER!

IT IS *ALWAYS* WHAT I HAVE WANTED--THROW IN A SET OF THESE DAINTY LITTLE UMBRELLAS AND YOU HAVE A *DEAL!*

THE NEXT DAY...

COMING THROUGH! MEDICAL EMERGENCY!

El Barto

AAAAAAH!

SCREECH!

75

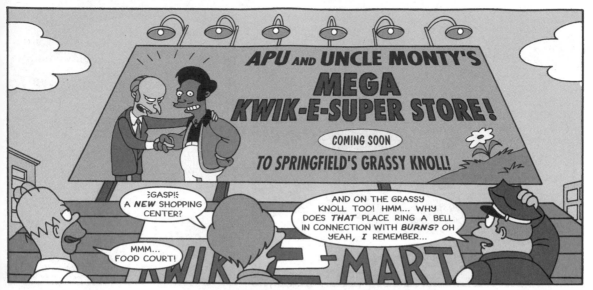

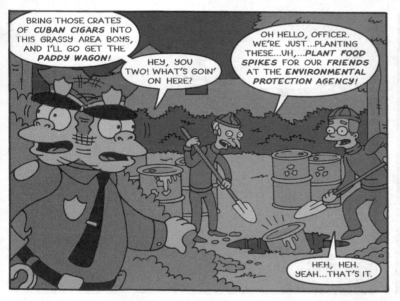

REMEMBER APU, *GREED* ISN'T AN *OPTION* FOR THE MODERN BUSINESSMAN--IT'S A *NECESSITY!* YOU HAVE TO CONVINCE YOURSELF THAT YOU DESERVE THE BEST! FROM NOW ON YOU'LL WEAR ONLY *ITALIAN SUITS!*

I HAVE ALWAYS FELT THAT I AM DESERVING OF THE BEST.

BUT UNTIL NOW, THE BEST CONSISTED OF *PROCESSED CHEESE* AND *SYNTHETIC FIBER BLENDS.*

HOW DO YOU LIKE YOUR LOBSTER THERMADORE?

IT IS MOST *APPETIZING!* AND NEVER HAVE I ENJOYED MELTED BUTTER IN SUCH *LARGE QUANTITY.*

S.S. WRITE-OFF

JUST STICK WITH ME MY HINDU FRIEND, AND *TOGETHER* WE'LL BUILD A KWIK-E-EMPIRE!

EXCELLENT!

EXCELLENT, *INDEED!*

LATER...

THANK YOU, LIMO DRIVER! I FOUND MY *COMPLIMENTARY BEVERAGE* MOST REFRESHING!

GOOD EVENING, UNCLE APU.

LETTER TO LANDLORD. IF YOU DO NOT FIX THE CRACK IN THE FRONT SIDEWALK BY NOON TOMORROW, I WILL UNLEASH A SPITEFUL FIRE OF LITIGATION THAT WILL STRIP YOU OF YOUR HOLDINGS AND LEAVE YOU A CHARRED SHELL OF THE MAN YOU ONCE WERE. ALL MY LOVE, APU.

IN CELEBRATION OF YOUR *NEW JOB,* UNCLE, I PREPARED YOU A *FEAST* OF ALU GOHBI AND VEGE-TABLE BYRANI.

I HOPE YOU ARE *HUNGRY!*

¿YAWN?...I AM TOO TIRED TO EAT, JAMSHED. BESIDES, I ALREADY ATE WITH MY *NEW EMPLOYER.* ACCORDING TO HIM, I SHOULD ONLY CONSUME *POWER FOODS* SUCH AS RAW BLUEFIN TUNA, CAVIAR, AND FREE-RANGE GAMECOCK! A *SMART* BOY LIKE YOU SHOULDN'T WASTE YOUR TIME MAKING SILLY DINNERS!

BUT UNCLE, I--

GO NOW AND STUDY THE DEPRECIATION OF THE JAPANESE YEN!

GOODNIGHT, NEPHEW! MAY ALL OF YOUR DREAMS BE *FINANCIALLY SECURE.*

MONTHS LATER...

HAS ANYBODY SEEN MY CLIP-ON TIE? I CAN'T FIND IT *ANYWHERE*.

GRRRRR

WELL, I'LL BE DOG-GONNED. *HERE* IT IS!

IF WE DON'T HURRY, WE'RE GOING TO BE LATE. APU WENT OUT OF HIS WAY TO INVITE US TO HIS STORE'S *GRAND OPENING!*

THE INVITATION ADVERTISED *FREE FOOD!*

WOO-HOO!

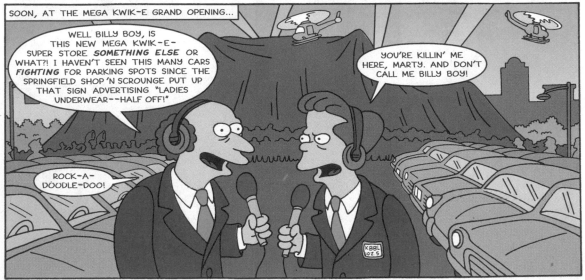

SOON, AT THE MEGA KWIK-E GRAND OPENING...

WELL BILLY BOY, IS THIS NEW MEGA KWIK-E-SUPER STORE *SOMETHING ELSE* OR WHAT?! I HAVEN'T SEEN THIS MANY CARS *FIGHTING* FOR PARKING SPOTS SINCE THE SPRINGFIELD SHOP 'N SCROUNGE PUT UP THAT SIGN ADVERTISING "LADIES UNDERWEAR--HALF OFF!"

YOU'RE KILLIN' ME HERE, MARTY. AND DON'T CALL ME BILLY BOY!

ROCK-A-DOODLE-DOO!

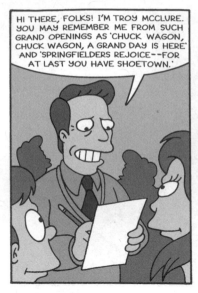

HI THERE, FOLKS! I'M TROY McCLURE. YOU MAY REMEMBER ME FROM SUCH GRAND OPENINGS AS 'CHUCK WAGON, CHUCK WAGON, A GRAND DAY IS HERE' AND 'SPRINGFIELDERS REJOICE--FOR AT LAST YOU HAVE SHOETOWN.'

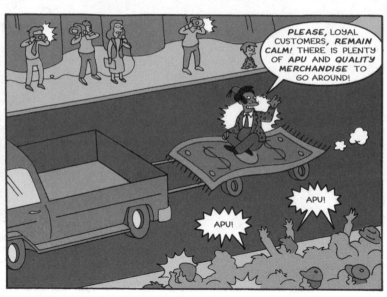

PLEASE, LOYAL CUSTOMERS, *REMAIN CALM!* THERE IS PLENTY OF *APU* AND *QUALITY MERCHANDISE* TO GO AROUND!

APU!

APU!

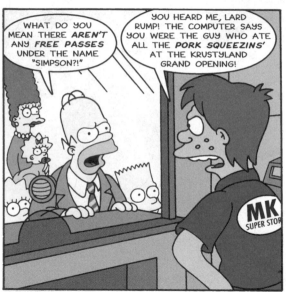

WHAT DO YOU MEAN THERE *AREN'T* ANY *FREE PASSES* UNDER THE NAME "SIMPSON?!"

YOU HEARD ME, LARD RUMP! THE COMPUTER SAYS YOU WERE THE GUY WHO ATE ALL THE *PORK SQUEEZINS'* AT THE KRUSTYLAND GRAND OPENING!

MK SUPER STORE

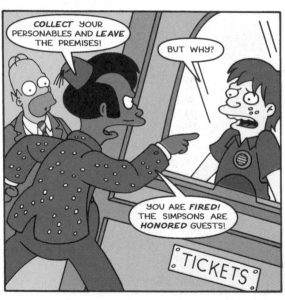

COLLECT YOUR PERSONABLES AND *LEAVE* THE PREMISES!

BUT WHY?

YOU ARE *FIRED!* THE SIMPSONS ARE *HONORED* GUESTS!

TICKETS

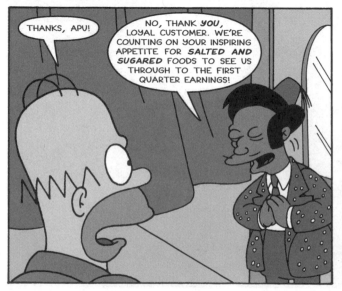

THANKS, APU!

NO, THANK *YOU*, LOYAL CUSTOMER. WE'RE COUNTING ON YOUR INSPIRING APPETITE FOR *SALTED AND SUGARED* FOODS TO SEE US THROUGH TO THE FIRST QUARTER EARNINGS!

TESTING...TESTING. *AHEM*...CAN I HAVE YOUR ATTENTION PLEASE?

WITHOUT FURTHER ADO, IT IS MY PLEASURE TO PRESENT TO THE PEOPLE OF SPRINGFIELD...

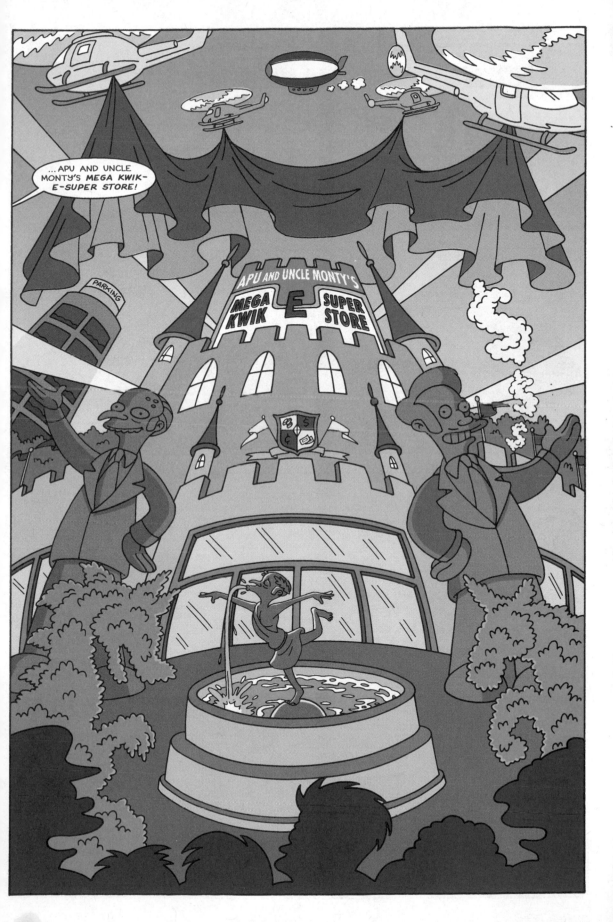

SOON, INSIDE THE RETAIL GIANT...

WHERE DO WE GO, HOMER?

THE SIGN SAYS I AM HERE. I'M GONNA GO OVER TO THAT SNACK BAR, BOY. TELL ME IF THE DOT MOVES TOO!

You are here!

ESIGH...WE'RE *DOOMED!*

HELLO, KIND AND LOYAL CUSTOMERS! WELCOME TO THE *LATEST* IN CONVENIENCE SHOPPING TECHNOLOGY. YOU ARE ABOUT TO ENTER A KWIK-E STORE UNLIKE ANY THAT HAS EVER ENJOYED YOUR PATRONAGE!

SO CLIMB ABOARD ONE OF OUR CONVENIENCE-INSPIRED CARRIAGES AND RELAX AS YOU ARE TREATED TO THE SIGHTS, SOUNDS, AND PUNGENT ODORS OF MY VERY OWN *FANTASY EXTRAVAGANZA!*

COOL, MAN! WE'RE RIDING IN A MEGA TANDOORI TACO!

MMM... FIBERGLASS!

HAVE A KWIK-E DAY!

KLANK!

A *HUNGRY* CUSTOMER IS ALWAYS WELCOME IN THE LAND OF LUNCHEON MEATS! FEEL FREE TO BUY *FAMILY-SIZE* HELPINGS. TODAY'S SPECIAL, PEANUT BUTTER-MARSHMALLOW SPREAD, IS AVAILABLE IN *FORTY GALLON ECONOMICAL DRUMS!*

THWAP!

LOOK, BOY! HEAD CHEESE! IN ALL THE *COLORS* OF THE WIND!

THE JUNGLE IS A VERY DANGEROUS PLACE, PATRON! BUT HERE, IN THE AUTO PARTS AMAZON, EVEN THE *WILDEST BREAKDOWN* CAN BE *EASILY TAMED!*

ACH! LET ME OUTA THIS CONTRAPTION! I'M IN *AUTO REPAIR HEAVEN!* I WANT THIS TO BE ME FINAL RESTIN' PLACE!

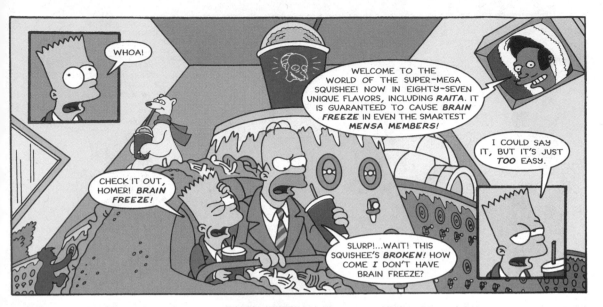

WHOA!

WELCOME TO THE WORLD OF THE SUPER-MEGA SQUISHEE! NOW IN EIGHTY-SEVEN UNIQUE FLAVORS, INCLUDING *RAITA*. IT IS GUARANTEED TO CAUSE *BRAIN FREEZE* IN EVEN THE SMARTEST *MENSA MEMBERS*!

I COULD SAY IT, BUT IT'S JUST *TOO* EASY.

CHECK IT OUT, HOMER! *BRAIN FREEZE!*

SLURP!...WAIT! THIS SQUISHEE'S *BROKEN!* HOW COME *I* DON'T HAVE BRAIN FREEZE?

MEANWHILE...

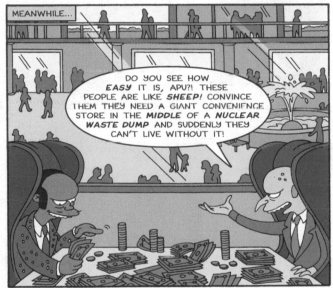

DO YOU SEE HOW *EASY* IT IS, APU?! THESE PEOPLE ARE LIKE *SHEEP*! CONVINCE THEM THEY NEED A GIANT CONVENIENCE STORE IN THE *MIDDLE* OF A *NUCLEAR WASTE DUMP* AND SUDDENLY THEY CAN'T LIVE WITHOUT IT!

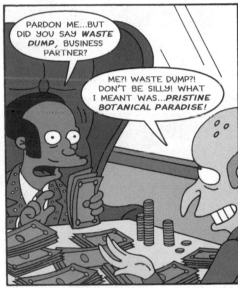

PARDON ME...BUT DID YOU SAY *WASTE DUMP*, BUSINESS PARTNER?

ME?! WASTE DUMP?! DON'T BE SILLY! WHAT I MEANT WAS...*PRISTINE BOTANICAL PARADISE!*

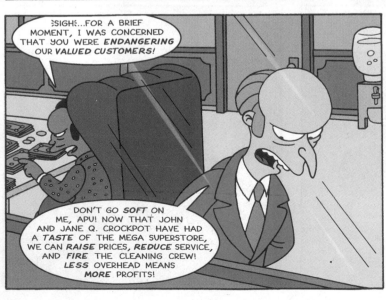

≡SIGH≡...FOR A BRIEF MOMENT, I WAS CONCERNED THAT YOU WERE *ENDANGERING* OUR *VALUED CUSTOMERS!*

DON'T GO *SOFT* ON ME, APU! NOW THAT JOHN AND JANE Q. CROCKPOT HAVE HAD A *TASTE* OF THE MEGA SUPERSTORE, WE CAN *RAISE* PRICES, *REDUCE* SERVICE, AND *FIRE* THE CLEANING CREW! *LESS* OVERHEAD MEANS *MORE* PROFITS!

MR. BURNS, YOUR IMPRESSIVE *SAVING SAVVY* NEVER CEASES TO AMAZE ME!! LET THE *COST CUTTING* BEGIN!

DAYS LATER...

AW, NUTS! *EVERYTHING* I CAME FOR IS CLOSED! THIS PLACE BREAKS DOWN MORE OFTEN THAN MY '73 *GREMLIN!*

DEPARTMENTS CLOSED DUE TO TECHNICAL FAILURE:

LIQUOR LOG CABIN
JERKY GYM
CHEESE WHEEL OF FORTUNE
MONTY'S MEDIEVAL MAGAZINE RACK

AH DONE GOT SOME MOLD SPORES GROWIN' IN TH' BACK! WANNA CHECK 'UM OUT?

I CAME IN HERE FOR DENTURE GUM AND *THIS* IS WHAT YOU SOLD ME! I WANT MY FIVE SPOT BACK *PRONTO!*

NO REFUNDS. BESIDES, YOU ALREADY OPENED THE PACKAGE WHICH NULLIFIES YOUR RIGHT TO RETURN THE GUM. IF YOU HADN'T *VIOLATED* THE PACKAGING, I COULD HAVE GIVEN YOU ANOTHER PACK OF *EQUAL OR LESSER VALUE,* BUT SINCE YOU DID, I CAN'T.

TO APPEAL THIS MATTER, PLEASE VISIT OUR COMPLAINTS DEPARTMENT.

COMPLAINTS DEPARTMENT

YOU GUYS CAN'T BRING YOUR *OWN* BEER NUTS IN HERE! I'LL GO *BROKE!*

THESE *BULK TUBS* FROM THE MEGA MART WERE TOO *CHEAP* TO PASS UP!

KWIK-E NO NAME BEER NUTS

KWIK-E NO NAME BEER NUTS

OF COURSE, WE COULD TAKE OUR *THIRST* TO APU'S LIQUOR LOUNGE...

⧼BURP⧽...OPEN THE BACK DOOR, WILL YA?! I BOUGHT *CHEESE FISH* TOO!

THAT NIGHT...

GOOD...EH...EVENING, LADIES AND GENTLEMEN. SETTLE DOWN! IN AN EFFORT TO...EH... STEM THE *FLOOD* OF ANGRY LETTERS TO MY OFFICE, I'VE INVITED YOU ALL HERE TO...EH...*VOICE* YOUR OPINIONS ON OUR TOWN'S LATEST BUSINESS VENTURE-- *THE MEGA KWIK-E-SUPER STORE!*

YOU HEARD THE MAN, PEOPLE! THE FORUM IS *OPEN!* IF ANYBODY HAS ANY APRICOT PRESERVES, HE OR SHE MAY ASK THE FIRST QUESTION!

WACK! WACK!

AAHRR!! I GOT SOMETHIN' TO SAY, YE BOTTOM SUCKIN' SEA URCHIN! MY *SEAFOOD STEAM TABLE* CAN'T KEEP UP WITH THE MEGA MART'S *CALAMARI SAMOSAS COUNTER!* I'M GOIN' UNDER AND DARN QUICK!

YOU? I HAVEN'T SOLD A *KRUSTYBURGER* IN WEEKS! APU'S *NAHASAPEEMAPETIPATTIES* ARE WIPIN' ME OUT!

THE STORE'S NOT EVEN OPEN TWENTY-FOUR HOURS! WHERE'S A KID TO GO AFTER THE SYMPHONY LETS OUT?

FRANKLY, I'M KINDA DISAPPOINTED BY THE LESS-THAN-CHALLENGING SHOPLIFTING!

ALL RIGHT, THAT'S ENOUGH! NOW I'M PERFECTLY AWARE THAT ALTHOUGH THE KWIK-E-SUPERSTORE IS BRINGING *TREMENDOUS* TAX DOLLARS INTO SPRINGFIELD, AHEM...THUS *PAYING* FOR MY *SUMMER VACATION* IN FIJI, IT'S ALSO *DECIMATING* THE MORALE OF OUR ESTABLISHED SMALL BUSINESS OWNERS AND... AHEM...OTHERS. THEREFORE, I'M GOING TO DO SOMETHING ABOUT IT!

WACK! CRACK!

EFFECTIVE *IMMEDIATELY*, I'M ESTABLISHING "THE KWIK-E-COMMISSION": A PANEL OF LOCAL BUSINESSMEN WHO WILL EXAMINE THE MEGA MART FOR ANY *FINANCIAL WRONG-DOING*, OR *CODE VIOLATIONS*. IF NONE ARE FOUND, WE...EH...WILL *DUMMY* SOME UP AND *PROSECUTE* TO THE FULL EXTENT OF THE LAW!

WAIT!!

MY UNCLE APU WOULD NEVER *HARM* ANY OF YOU! YOU ARE HIS VALUED FRIENDS AND CUSTOMERS. HIS BREAD AND *PROVERBIAL* BUTTER!

BUT THE MEGA MART HAS BECOME A *MEGA-RIP-OFF*, JAMSHED!

THAT IS BECAUSE MY UNCLE WAS BRAINWASHED BY HIS PARTNER, MISTER MONTGOMERY BURNS! IF YOU WILL HELP HIM SNAP OUT OF IT, I PROMISE YOU THE OLD APU WILL PUT AN *END* TO THIS FOOLISHNESS ONCE AND FOR ALL!

HOW DO WE KNOW THIS ISN'T SOME KIND OF *TRICK*, WOODSHED?

THE NAME IS JAMSHED, AND BECAUSE I AM WILLING TO SWEAR ON THE *BHAGAVAD-GITA*, IT SHALL BE DONE!

LATER...

THANKS TO THE HANDS OF THIS GIFTED ESTHETICIAN, MY SKIN IS CLEAN AND REFRESHED!

WHAT ARE YOU DOING, UNCLE?

SEE FOR YOURSELF!

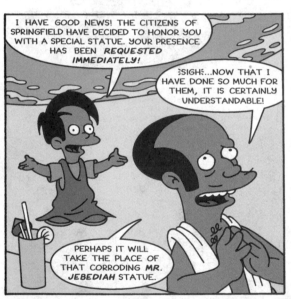

I HAVE GOOD NEWS! THE CITIZENS OF SPRINGFIELD HAVE DECIDED TO HONOR YOU WITH A SPECIAL STATUE. YOUR PRESENCE HAS BEEN *REQUESTED IMMEDIATELY!*

SIGH!...NOW THAT I HAVE DONE SO MUCH FOR THEM, IT IS CERTAINLY UNDERSTANDABLE!

PERHAPS IT WILL TAKE THE PLACE OF THAT CORRODING *MR. JEBEDIAH* STATUE.

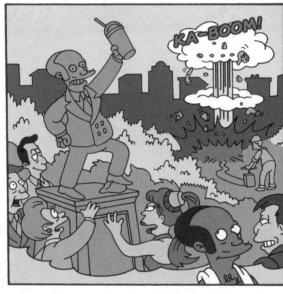

KA-BOOM!

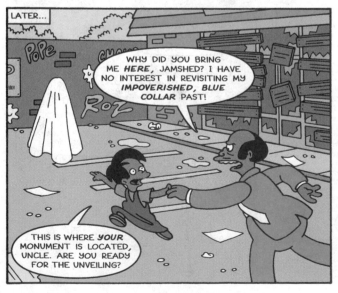

LATER...

WHY DID YOU BRING ME *HERE*, JAMSHED! I HAVE NO INTEREST IN REVISITING MY *IMPOVERISHED, BLUE COLLAR* PAST!

THIS IS WHERE *YOUR* MONUMENT IS LOCATED, UNCLE. ARE YOU READY FOR THE UNVEILING?

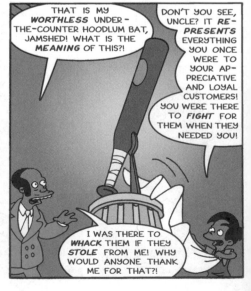

THAT IS MY *WORTHLESS* UNDER-THE-COUNTER HOODLUM BAT, JAMSHED! WHAT IS THE *MEANING* OF THIS?!

DON'T YOU SEE, UNCLE? IT *RE-PRESENTS* EVERYTHING YOU ONCE WERE TO YOUR AP-PRECIATIVE AND LOYAL CUSTOMERS! YOU WERE THERE TO *FIGHT* FOR THEM WHEN THEY NEEDED YOU!

I WAS THERE TO *WHACK* THEM IF THEY *STOLE* FROM ME! WHY WOULD ANYONE THANK ME FOR THAT?!

THE BOY'S RIGHT, APU. WHEN I WAS FIRED FOR THE *ELEVENTH* TIME AND WAS UP ALL NIGHT WANDERING THE COLD AND EMPTY STREETS, YOU WERE THERE WITH A *WARM CUP OF COFFEE* AND A *STICKY BUN!*

AND THANK GOLLY-GOODNESS WHEN MY LITTLE MRS. WAS EXPECTING THE STORK, YOU SUPPLIED US WITH ALL THE MIDNIGHT *SARDINES* AND *TAPIOCA PUDDING* SHE COULD EAT!

AND DON'T FORGET THE *EMERGENCY NICOTINE PATCHES* SELMA AND I NEEDED WHEN WE TRIED TO QUIT SMOKING BACK IN '89!

...AND '90... AND '93...AND '94...

UH, HUH.

AND WHO'S GONNA GIVE ME *ONE THIRD OFF* ON SQUISHEES WHEN I FLUNK MY NEXT MATH EXAM?

YOU SEE, UNCLE, *TRUE WEALTH* COMES NOT FROM MONEY, BUT FROM THE LOVE AND RESPECT OF OTHERS. BY THAT RECKONING, YOU ARE LIVING NOT VERY LARGE!

I AM MOST APOLOGETIC! HAVE I *DESTROYED* THE ONLY THING THAT REALLY MATTERS?

IT SEEMS I HAVE BEEN A TURKEY OF *MEGA-PROPORTIONS!* IF IT IS NOT TOO LATE, I AM GOING TO STOP THE MEGA MART BEFORE IT *RUINS EVERY-THING!*

I HAVE LEARNED FROM THE *BEST*, LOYAL NEPHEW. I HAVE NO CHOICE BUT TO *OUT-SNOW* THE SNOWMAN!

BUT HOW, UNCLE?

MR. BURNS HAS TOLD ME THINGS ABOUT THE MEGA MART PROPERTY NO ONE ELSE KNOWS! HE WILL SOON WISH HE HAD DONE *OTHERWISE!*

APU! WHAT DO YOU MEAN BY *WAKING* ME IN THE MIDDLE OF THE NIGHT AND *DEMANDING* THAT I COME DOWN HERE?

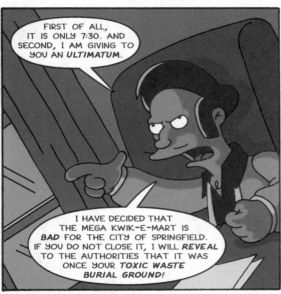

FIRST OF ALL, IT IS ONLY 7:30. AND SECOND, I AM GIVING TO YOU AN *ULTIMATUM*.

I HAVE DECIDED THAT THE MEGA KWIK-E-MART IS *BAD* FOR THE CITY OF SPRINGFIELD. IF YOU DO NOT CLOSE IT, I WILL *REVEAL* TO THE AUTHORITIES THAT IT WAS ONCE YOUR *TOXIC WASTE BURIAL GROUND!*

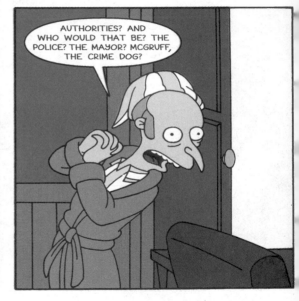

AUTHORITIES? AND WHO WOULD THAT BE? THE POLICE? THE MAYOR? MCGRUFF, THE CRIME DOG?

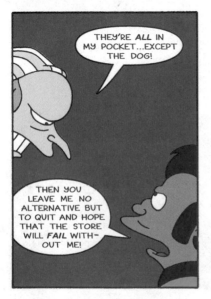

THEY'RE *ALL* IN MY POCKET...EXCEPT THE DOG!

THEN YOU LEAVE ME NO ALTERNATIVE BUT TO QUIT AND HOPE THAT THE STORE WILL *FAIL* WITH-OUT ME!

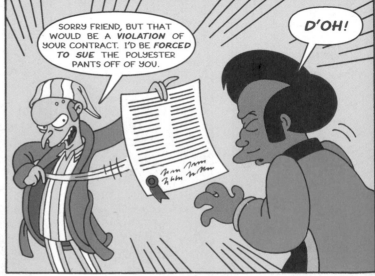

SORRY FRIEND, BUT THAT WOULD BE A *VIOLATION* OF YOUR CONTRACT. I'D BE *FORCED TO SUE* THE POLYESTER PANTS OFF OF YOU.

D'OH!

I MUST CONFESS, JAMSHED, I AM AT THE POINT OF MY WITS FROM WHERE I CAN GO NO FURTHER.

IF ONLY SOMEONE COULD TELL ME HOW TO RIGHT MY WRONGS, AND RETURN THE KWIK-E-MART TO NORMAL, I WOULD SURELY HEED THEIR ADVICE.

¡GROAN!¡

WHY NOT CONSULT WITH THE ORIGINAL BENEVOLENT AND ENLIGHTENED PRESIDENT AND C.E.O. OF KWIK-E-MART?

JAMSHED! YOU ARE A PINT-SIZED GENIUS! OF COURSE! HIS HOLINESS IS THE ONLY MAN ALIVE WHO MAY BE ABLE TO HELP ME.

SOON...

BELOVED INDIA, I AM COMING HOME TO YOU ONCE MORE!

HOUSE OF TOO MUCH YARN

MUCH HAS CHANGED SINCE LAST I WAS HERE. I HOPE THE EXALTED ONE IS STILL AT HIS POST.

MASTER! I HAVE NEED OF YOUR ENLIGHTENED COUNSEL!

APPROACH, MY SON!

YARN 50¢

AND SOON...

AND NOW, CHARLES MONTGOMERY BURNS, YOU WILL LEARN...

SOON YOUR BUTT WILL BE MADE OF GRASS AND I WILL BE THE LAWN MOWER!

THE FOLLOWING WEEK...

HEY, APU, TELL US AGAIN HOW YOU FORCED MR. BURNS TO *CLOSE* THE MEGA KWIK-E-MART, AND GOT YOUR ORIGINAL STORE *BACK!*

YEAH, TELL US APU!

OKAY, ALL RIGHT! WHEN I BROUGHT MY PROBLEM TO THE FORMER PRESIDENT, HE INFORMED ME OF A *CLAUSE* IN THE CONTRACT FOR THE SALE OF THE KWIK-E-MART INTERNATIONAL TO BURNS INDUSTRIES.

THIS FINE-PRINT PARAGRAPH, WRITTEN IN *SANSKRIT,* STATED *CLEARLY* THAT "PERSONS ENTERING THE STORE WITHOUT A SHIRT OR SHOES, MAY NOT BE THE *RECIPIENTS OF SERVICE...*

...AND *VIOLATION* OF THIS RULE AT ANY FUTURE TIME OR PLACE THROUGHOUT THE KNOWN UNIVERSE WILL CAUSE THE KWIK-E-MART INTERNATIONAL TO *REVERT BACK* TO ITS *ORIGINAL OWNER."*

AS YOU CAN SEE, THE RULE WAS *VIOLATED* ON THIS AND SEVERAL OTHER OCCASIONS.

WELL, THAT'S ABOUT IT.

WAIT! YOU FORGOT ABOUT THE BEST PART!

OH *HEAVENS,* LET'S NOT FORGET TO TELL THE *BEST* PART.

OH, YOU MEAN THE PART ABOUT THE CONTRACT VIOLATOR ALSO BEING *FORCED* TO WORK FOR KWIK-E-MART INTER-NATIONAL FOR A PERIOD OF NO LESS THAN SIX EIGHT-HOUR SHIFTS?

THAT'S THE ONE!

UM...YOU *MISSED* A SPOT, SIR.

MISS *THIS,* YOU BLITHERING BUCKETHEAD!

HA!

HOO HA!

HA HA!

HA HA HA!

HOO HOO!

THE END

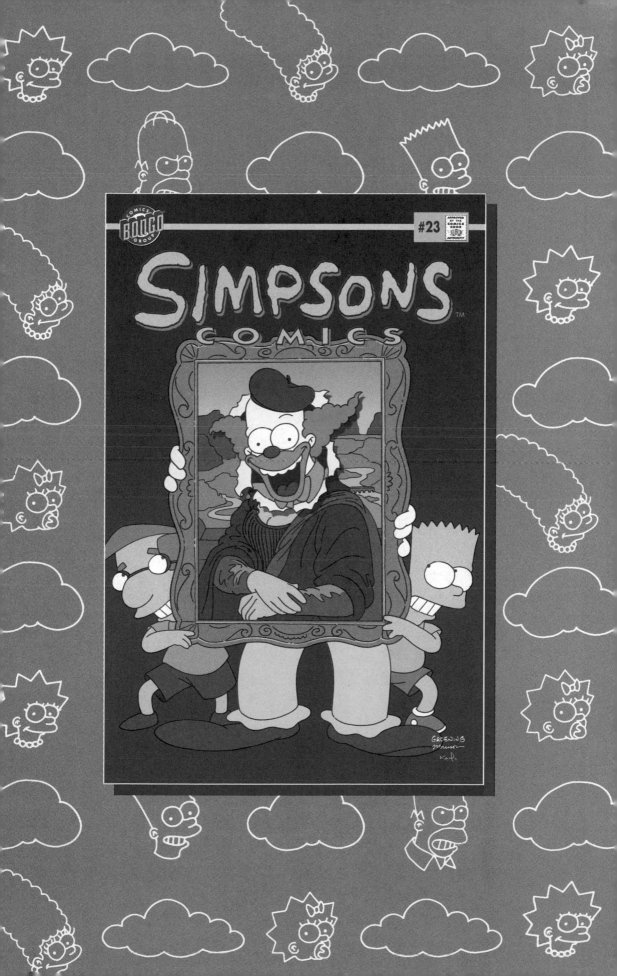

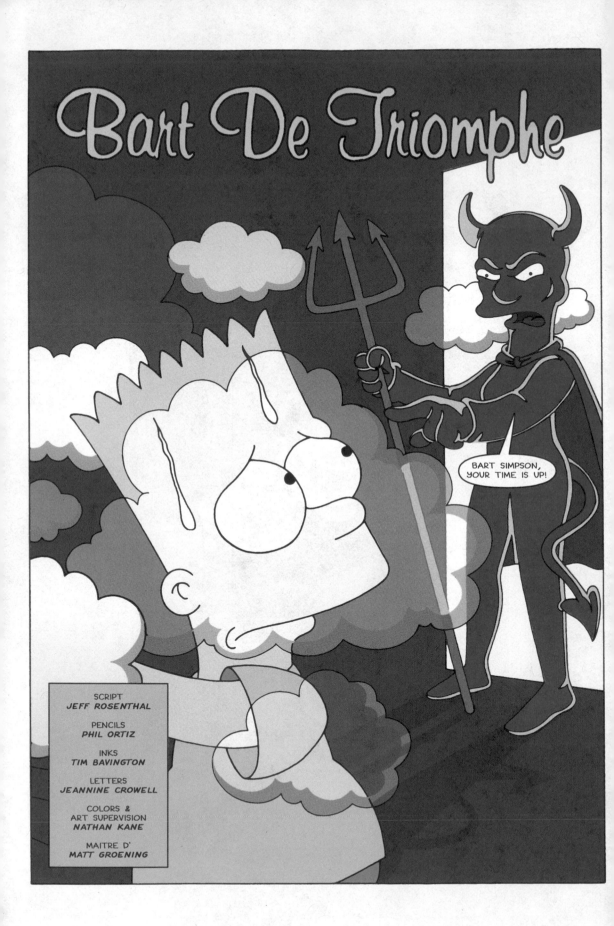

I WILL NOT GOSSIP ABOUT INTER-FACULTY RELATIONSHIPS
I WILL NOT GOSSIP ABOUT INTER-FACULTY RELATIONSHIPS
I WILL NOT GOSSIP ABOUT INTER-FACULTY RELATIONSHIPS
I WILL NOT GOSSIP ABOUT INTER-FACULTY RELATIONSHIPS

NOW GET OUT OF HERE. I'M *LATE* FOR REVEREND LOVEJOY'S 5TH ANNUAL COUNTDOWN TO ARMAGEDDON COSTUME CARNIVAL.

SOUNDS LIKE THE OL' REV HAS HIT THE SNOOZE BUTTON ON HIS FUN CLOCK.

AHRIGHT LASSIE, I'M DONE WAXIN' THE HALLWAY. ARE YOU READY TA GO?

DO YOU THINK *RED* IS MY COLOR?

AH'M PARTIAL TO *PLAID* MESELF.

THERE IS ONE ADVANTAGE TO BEING KEPT AFTER SCHOOL CLEANING ERASERS.

MARTIN FOR CLASS PRESIDENT (He's *two* reading levels *AHEAD* of his grade)

THESE FRESHLY WAXED FLOORS GIVE ME THE SPEED I NEED TO NAVIGATE THESE EMPTY HALLWAYS WITH STYLE AND...

NELSON 4 PREZ... OR ELSE!

AY, CARAMBA!!

OUTTA MY WAY!!

STOP HIM!!

SKREEECH!

WHAM·O!

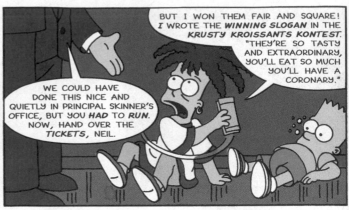

WE COULD HAVE DONE THIS NICE AND QUIETLY IN PRINCIPAL SKINNER'S OFFICE, BUT YOU *HAD* TO *RUN*. NOW, HAND OVER THE *TICKETS*, NEIL.

BUT I WON THEM FAIR AND SQUARE! *I* WROTE THE *WINNING SLOGAN* IN THE *KRUSTY KROISSANTS KONTEST*. "THEY'RE SO TASTY AND EXTRAORDINARY, YOU'LL EAT SO MUCH YOU'LL HAVE A CORONARY."

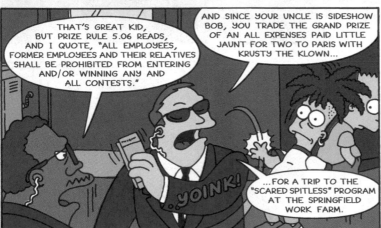

THAT'S GREAT KID, BUT PRIZE RULE 5.06 READS, AND I QUOTE, "ALL EMPLOYEES, FORMER EMPLOYEES AND THEIR RELATIVES SHALL BE PROHIBITED FROM ENTERING AND/OR WINNING ANY AND ALL CONTESTS."

AND SINCE YOUR UNCLE IS SIDESHOW BOB, YOU TRADE THE GRAND PRIZE OF AN ALL EXPENSES PAID LITTLE JAUNT FOR TWO TO PARIS WITH KRUSTY THE KLOWN...

...FOR A TRIP TO THE "SCARED SPITLESS" PROGRAM AT THE SPRINGFIELD WORK FARM.

YOINK!

I GOTTA GET TO A PAY PHONE. I'LL BET DAVE SHUTTON WOULD PAY A *BUNDLE* TO GET THIS *SCOOP* FOR HIS INVESTIGATIVE SHOW, "SHUTTON DOWN FRAUD."

LISTEN KID, WHY DON'T YOU JUST *FORGET* WHAT YOU SAW HERE TODAY.

WELL, I'LL TELL YA MISTER, I CAN GET *REEEAAL* FORGETFUL-LIKE.

OKAY KID, I GET IT. TAKE THESE!

WOO-HOO LA LA! TWO ROUND TRIP TICKETS TO PARIS! GENTLE-MEN, CONSIDER ME MARCEL MARCEAU.

REMEMBER, YOU MUST BE ACCOMPANIED BY A CHAPERONE WHO IS *AT LEAST* EIGHTEEN YEARS OLD. *HUMANS ONLY!* KRUSTY NOW KNOWS HOW TO SPOT A BUNCH OF DOGS IN A TRENCH COAT.

THE NEXT DAY...

I'VE GOTTA FIND SOMEONE *COOL* TO BE MY CHAPERONE, AND QUICK! IF WORD OF THIS EXTRA TICKET LEAKS OUT TO MY FAMILY, IT COULD BE *DISASTROUS!*

AND LET FIFI, THE *CHAMBERMAID*, PAW THROUGH MY LUGGAGE LOOKING FOR SOME *CHIC AMERICAN FASHIONS?* FORGET IT.

COULDN'T WE HAVE LEFT YOUR BAGS IN THE HOTEL?

NDROID'S DUNGEON
SEBALL CARD SHOP

YES, WE'RE OPEN

RADIOACTIVE M
WANTS YOU!!

MILHOUSE? IS THAT YOU?

SHH! CAREFUL, BART, NO ONE CAN KNOW IT'S ME.

I WANTED TO CHECK THIS OFFER OUT BUT I'M NOT ALLOWED INSIDE, REMEMBER?* SO, I BORROWED THIS FAKE BEARD THAT MY DAD WORE AT REVEREND LOVEJOY'S PARTY.

I DON'T KNOW ANY COMMANDMENT THAT SAYS, "THOU SHALT NOT WEAR PHONY FACIAL HAIR."

RADIOACTIVE M
WANTS YOU!!
TO JOIN THE BATTLE AGAINST RADICALS WEIRDOS, AND WHINERS. BECOME AN HONORARY MEMBER OF THE SUPERIOR SQUAD · DETAILS INSIDE.

*EDITOR'S NOTE: SEE MILHOUSE #1

I SUPPOSE YOU ARE HERE TO ACQUIRE A FREE SUPERIOR SQUAD ID, WHICH IS AN EXACT REPLICA OF THOSE CARRIED BY ALL MEMBERS OF THE SQUAD. YOU WILL NOTE THAT IT HAS SPACES FOR YOUR NAME, AGE, AND SUPERHERO ALIAS WHICH YOU MAY NOW FILL OUT.

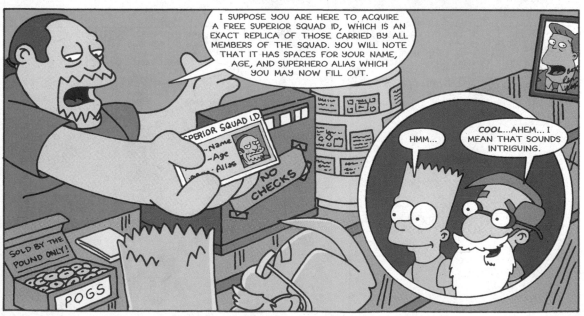

PERIOR SQUAD I.D.
-Name
-Age
-Alias

NO CHECKS

SOLD BY THE POUND ONLY!

POGS

HMM...

COOL...AHEM... I MEAN THAT SOUNDS INTRIGUING.

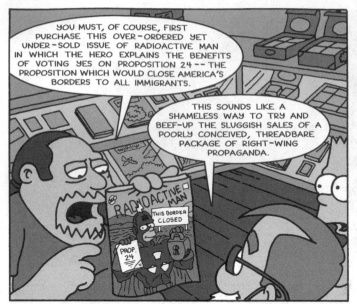

YOU MUST, OF COURSE, FIRST PURCHASE THIS OVER-ORDERED YET UNDER-SOLD ISSUE OF RADIOACTIVE MAN IN WHICH THE HERO EXPLAINS THE BENEFITS OF VOTING YES ON PROPOSITION 24 -- THE PROPOSITION WHICH WOULD CLOSE AMERICA'S BORDERS TO ALL IMMIGRANTS.

THIS SOUNDS LIKE A SHAMELESS WAY TO TRY AND BEEF-UP THE SLUGGISH SALES OF A POORLY CONCEIVED, THREADBARE PACKAGE OF RIGHT-WING PROPAGANDA.

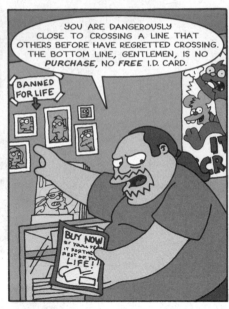

YOU ARE DANGEROUSLY CLOSE TO CROSSING A LINE THAT OTHERS BEFORE HAVE REGRETTED CROSSING. THE BOTTOM LINE, GENTLEMEN, IS NO PURCHASE, NO FREE I.D. CARD.

BANNED FOR LIFE

BUY NOW OR YOU'LL BE SORRY THE REST OF YOUR LIFE!!

HE'LL TAKE ONE!

BUT, BART, I DON'T REALLY WANT--

TRUST ME, PAL. IT'S ALL PART OF THE PLAN.

IN A MOMENT...

THERE YOU ARE. I HAVE DONE YOU THE SERVICE OF LAMINATING YOUR ID FREE OF CHARGE, MR. LATREC.

AW, COOL!

IF KRUSTY FALLS FOR YOUR ID, BY THIS TIME TOMORROW WE'LL BE ON A CONCORDE TO EUROPE.

AT THE VERY LEAST WE CAN GET IN TO SEE MCBAIN'S LATEST R-RATED FEATURE, "THE WINTER OF MY DISMEMBERMENT," WITHOUT A PARENT OR GUARDIAN.

SUPERIOR SQUAD I.D.

NAME - Lou La Trec
AGE - 35
ALIAS - Eagle Eye

THE NEXT MORNING...

REMIND ME *WHY* I'M NOT TELLING MOM AND DAD THAT YOU ARE HEADING TO FRANCE WITH AN *IMPROPER CHAPERONE.*

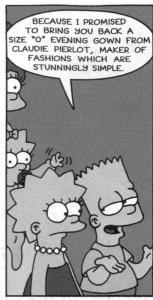

BECAUSE I PROMISED TO BRING YOU BACK A SIZE "O" EVENING GOWN FROM CLAUDIE PIERLOT, MAKER OF FASHIONS WHICH ARE STUNNINGLY SIMPLE.

ESIGH:...OH, RIGHT. SOMETHING THAT A YOUNG FRENCHWOMAN MIGHT WEAR WHILE ACCOMPANYING HER STRUGGLING ARTIST BOYFRIEND ALONG THE BANKS OF THE SEINE OR OUT TO THE THEATRE DES CHAMPS-ELYSEES TO SEE A SCANDALOUS PERFORMANCE OF STRAVINSKY'S "LE SACRE DU PRINTEMPS." AH, TO BE IN LOVE IN PARIS.

THAT'S A LOT TO ASK FROM ONE DRESS, LIS. AH, HERE COMES THE INTERNATIONAL AMBASSADOR OF AMUSEMENT NOW.

OH BROTHER, KIDS! KIDS, KIDS, KIDS. JUST ONCE I'D LIKE TO HAVE A CONTEST THAT ONLY LEGGY BLONDES CAN ENTER.

NOW, YOU BOYS HAVE A *SAFE* TRIP, *BEHAVE* YOURSELVES AND *ENJOY* THE FINE ART AND EXQUISITE CUISINE.

YEAH BOY, WHEN YOU GET HOME YOU CAN TELL ME ALL ABOUT WHAT IT'S LIKE TO EAT *REAL* FRENCH DELICACIES. MMM...FRENCH FRIES...FRENCH TOAST...FRENCH CUT GREEN BEANS!

I CAN'T *BELIEVE* YOU *FORGOT* THE BEARD! WE'RE SUNK.

YOU LOOK A *LOT YOUNGER* WITHOUT THE BEARD, LOU. YOU'RE LUCKY ALL YOU'VE GOTTA DO IS SHAVE-- I'VE GOTTA PAY SOME BEVERLY HILLS PLASTIC SURGEON A YEAR'S WORTH OF PRODUCT ENDORSEMENT MONEY TO KEEP MY BOYISH GOOD LOOKS.

MEANWHILE, SOMEWHERE IN FRANCE...

< PLEASE, I BEG OF YOU, *DON'T* DO IT. >*

< YOU'LL BE MAKING A *TERRIBLE MISTAKE*. >

*TRANSLATED FROM FRENCH, THE LANGUAGE OF FRENCH PEOPLE & SOME CANADIANS.

< IT IS *YOU* WHO WILL BE MAKING A TERRIBLE MISTAKE IF YOU COME ANY CLOSER. >

< WE HAVE ENOUGH PEPPER HERE TO TURN THESE RICH SAUCES INTO *FOUL TASTING SWILL* EVEN A SWINE WOULD NOT EAT. >

< BUT THE *PRISON INMATES* ARE EXPECTING SCALLOPS IN A DELICATE WHITE WINE SAUCE. >

< IF YOU DO THIS, THERE WILL BE A *RIOT* NOT SEEN SINCE THE STORMING OF THE BASTILLE. >

SUDDENLY...

< DROP THE PEPPER! >

WHAM!

< IF YOU *INSIST*. >

< NO!!! >

AFTER A LONG FLIGHT AND A BUMPY RIDE IN A TAXI...

I'M STILL NOT CLEAR ON THE MONETARY CONVERSION RATES, BUT HERE'S A TIP.

Le TAXI

TEN CENTIMES!?! *COUP MOI!*

YOU'RE WELCOME.

*BITE ME!

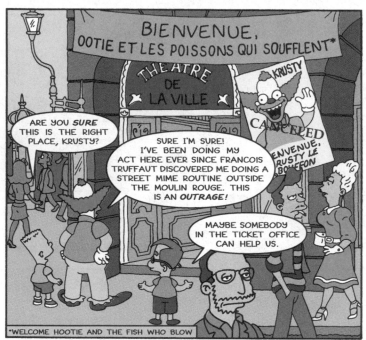

BIENVENUE, OOTIE ET LES POISSONS QUI SOUFFLENT*

THÉATRE DE LA VILLE

KRUSTY
CANCELED
BIENVENUE, RUSTY LE BOUFFON

ARE YOU *SURE* THIS IS THE RIGHT PLACE, KRUSTY?

SURE I'M SURE! I'VE BEEN DOING MY ACT HERE EVER SINCE FRANCOIS TRUFFAUT DISCOVERED ME DOING A STREET MIME ROUTINE OUTSIDE THE MOULIN ROUGE. THIS IS AN *OUTRAGE!*

MAYBE SOMEBODY IN THE TICKET OFFICE CAN HELP US.

*WELCOME HOOTIE AND THE FISH WHO BLOW

LET ME TALK TO HIM. I DOZED OFF LISTENING TO "TROY MCCLURE'S LEARN FRENCH TOOT SWEET WHILE YOU SLEEP" ON THE PLANE LAST NIGHT.

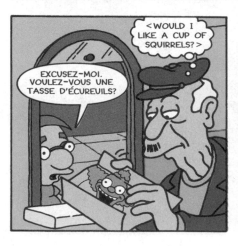

< WOULD I LIKE A CUP OF SQUIRRELS? >

EXCUSEZ-MOI. VOULEZ-VOUS UNE TASSE D'ÉCUREUILS?

< WHAT? >

LET ME TRY, MILHOUSE. PARLEZ-VOUS ANGLAIS?

OUI.

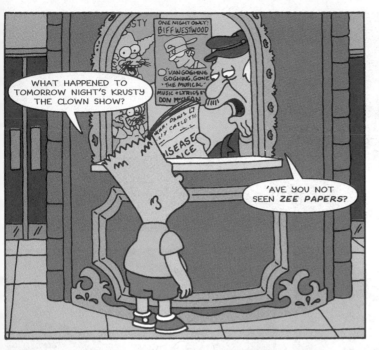

WHAT HAPPENED TO TOMORROW NIGHT'S KRUSTY THE CLOWN SHOW?

'AVE YOU NOT SEEN *ZEE PAPERS?*

ONE NIGHT ONLY! BIFF WESTWOOD

"VAN GOGHING GOGHING, GONE" THE MUSICAL

MUSIC + LYRICS BY DON McLEAN

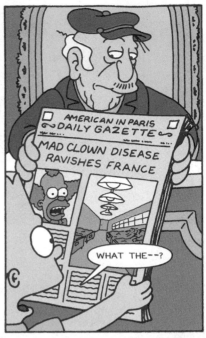

AMERICAN IN PARIS DAILY GAZETTE

MAD CLOWN DISEASE RAVISHES FRANCE

WHAT THE--?

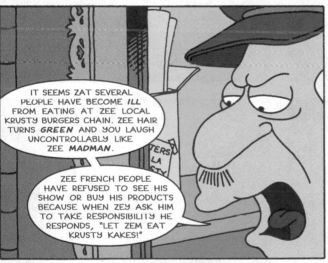

IT SEEMS ZAT SEVERAL PEOPLE HAVE BECOME *ILL* FROM EATING AT ZEE LOCAL KRUSTY BURGERS CHAIN. ZEE HAIR TURNS *GREEN* AND YOU LAUGH UNCONTROLLABLY LIKE ZEE *MADMAN.*

ZEE FRENCH PEOPLE HAVE REFUSED TO SEE HIS SHOW OR BUY HIS PRODUCTS BECAUSE WHEN ZEY ASK HIM TO TAKE RESPONSIBILITY HE RESPONDS, "LET ZEM EAT KRUSTY KAKES!"

THAT WAS A *JOKE!* BESIDES, KRUSTY KAKES ARE "YUMMERIFFIC! HO, HO, HEY!" HUH? HUH? NOTHIN'!

HEY, WHAT IF WE MAKE YOUR SHOW A BENEFIT? ALL THE PROCEEDS COULD GO TO BUY NEW *STOMACH PUMPS* FOR THE LOCAL HOSPITALS!

FORGET IT, KID. I DIDN'T COME HERE TO *LOSE MONEY.*

BESIDES, IT'S NOT MY FAULT! WHAT WAS I SUPPOSED TO DO, WAIT FOR THE FDA TO GREEN-LIGHT THE MOST COST-EFFECTIVE BEEF BY-PRODUCTS PRESERVATIVE OF ALL TIME? *I'M ONLY HUMAN!!*

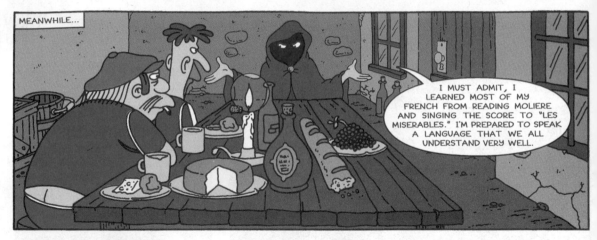

MEANWHILE...

I MUST ADMIT, I LEARNED MOST OF MY FRENCH FROM READING MOLIERE AND SINGING THE SCORE TO "LES MISERABLES." I'M PREPARED TO SPEAK A LANGUAGE THAT WE ALL UNDERSTAND VERY WELL.

SACRE BLEU!

'OW MUCH EEZ ZERE?

TWO MILLION FRANCS IN *GOLD*! ALL YOURS IF YOU ACCOMPLISH THE TASK FOR WHICH YOU HAVE BEEN HIRED.

BUT WHY US?

BECAUSE, YOU SEE, GENTLEMEN, WE HAVE SOMETHING IN *COMMON*.

¡GASP!¡

JUST TELL US WHAT TO DO AND WE'LL DO EET!

GENTLEMEN, IT STARTS WITH A *REPLICA* OF THE MOST INFECTIOUS COME-HITHER SMILE KNOWN TO MAN.

IT LOOKS *EXACTLY* LIKE ZEE *REAL* THING!

IT'S *AMAZING* WHAT YOU CAN DO WITH A *PAINT-BY-NUMBERS KIT*. THE TRICK IS IN THE BLENDING.

THE NEXT DAY...

C'MON, KRUSTY, YOU'VE GOTTA PULL YOURSELF TOGETHER. YOU'RE STILL *LOVED* IN THE U.S., GERMANY, AND THE AUSTRALIAN OUTBACK.

THANKS FOR NOTHIN, KID. I'M GOING TO MY TIMESHARE IN ZURICH, SO WHY DON'T YOU GUYS AMSCRAY FOR AWHILE.

< MAY I INTEREST YOU IN CRUSHED ICE WITH SYRUP? >

LE CART DE GICLEMENT-EE*

WELL, BART, NOW THAT KRUSTY'S SHOW'S BEEN CANCELED, WHAT ARE WE GOING TO DO?

*THE CART OF SQUISH-EE

LET'S GET SOMETHING TO EAT AND SEE IF WE CAN FIND SOME KIND OF GUIDEBOOK. THERE'S GOTTA BE SOMETHING TO DO AROUND THIS TOWN.

< MY COUSIN APU IS RIGHT. THE FRENCH DON'T APPRECIATE THE SUBTLE JOYS OF *FROZEN, SUGAR-FILLED REFRESHMENTS.* >

HEY, HERE'S ONE NOW! HOW CONVENIENT!

AN ALLOWANCE SAVER'S GUIDE TO PARIS

IT SAYS THERE ARE TWO NEW EXHIBITS AT THE LOUVRE. "MONET OR MANET: A CENTURY OF CONFUSION" AND "THE HISTORY OF THE SLINGSHOT: FROM DAVID TO DENNIS!"

AN ALLOWANCE SAVERS GUIDE TO PARIS

THE HISTORY OF THE SLINGSHOT! MILHOUSE, IT LOOKS AS IF *FATE* HAS SHOWN US THE WAY. C'MON MOVE IT OR LOUVRE IT!

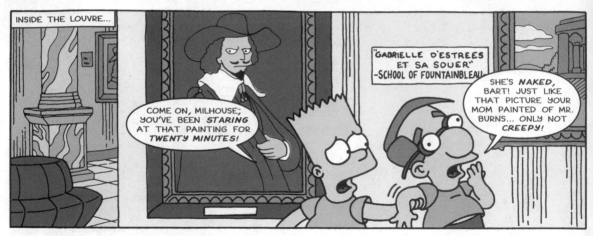

INSIDE THE LOUVRE...

COME ON, MILHOUSE; YOU'VE BEEN *STARING* AT THAT PAINTING FOR *TWENTY MINUTES!*

"GABRIELLE D'ESTREES ET SA SOUER" -SCHOOL OF FOUNTAINBLEAU

SHE'S *NAKED*, BART! JUST LIKE THAT PICTURE YOUR MOM PAINTED OF MR. BURNS... ONLY NOT *CREEPY!*

C'MON, MILHOUSE, WE'RE HERE TO SEE THE *TECHNOLOGICAL PROGRESS* THAT A BOY'S BEST FRIEND HAS ACHIEVED THROUGH THE YEARS.

"THE HISTORY OF THE SLING SHOT EXHIBIT THIS WAY

HEY, THIS ISN'T THE SLINGSHOT EXHIBIT.

THIS IS WHERE THE MONA LISA IS...OR WAS.

DAVINCI'S "MONA LISA"

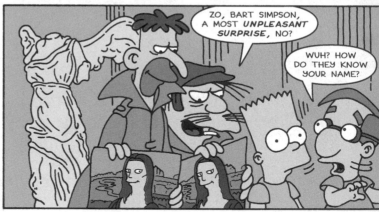

ZO, BART SIMPSON, A MOST *UNPLEASANT SURPRISE,* NO?

WUH? HOW DO THEY KNOW YOUR NAME?

I DON'T *BELIEVE* IT-- *UGOLIN AND CESAR!* THEY'RE THE GUYS WHO FED ME DAY-OLD BREAD AND FORCED ME TO WORK FOR THEM DAY AND NIGHT WITHOUT A PROPER BED, WARM CLOTHES OR CABLE TV!

AND YOU REPAID US BY TURNING US IN FOR SELLING WINE TAINTED WITH ANTI-FREEZE.

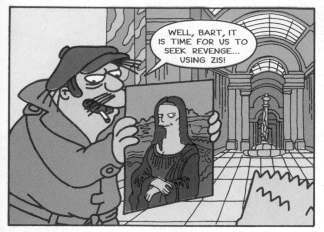

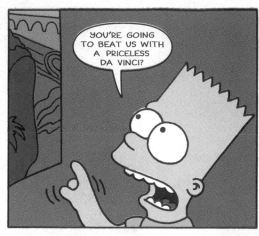

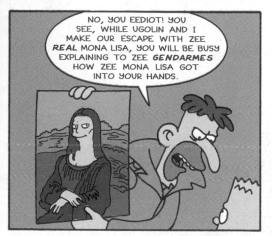

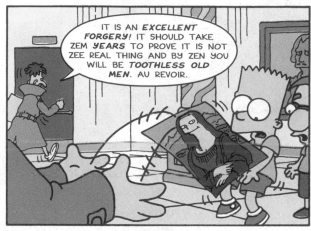

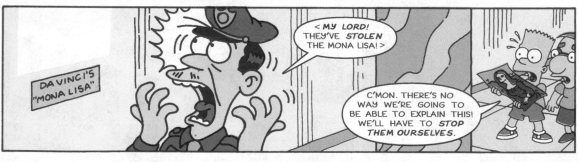

105

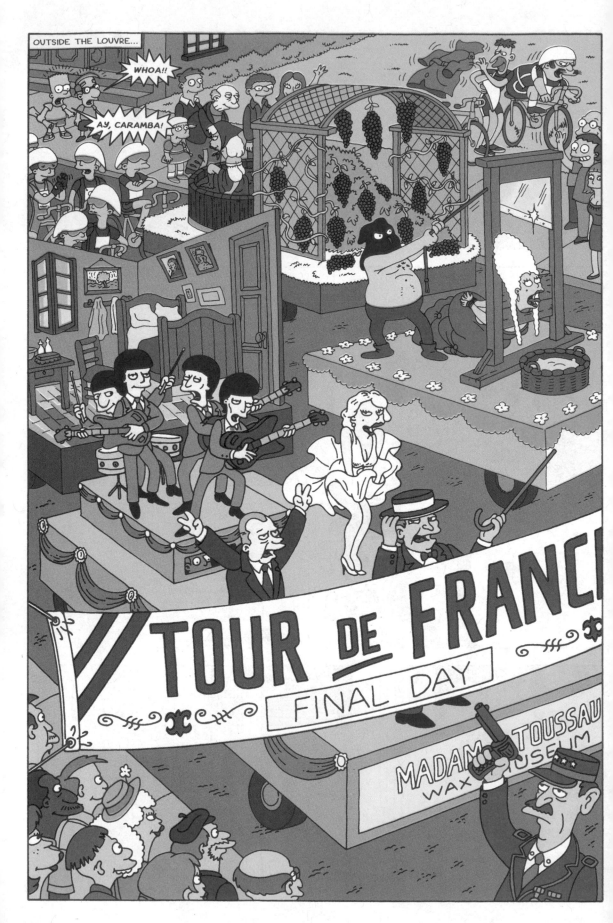

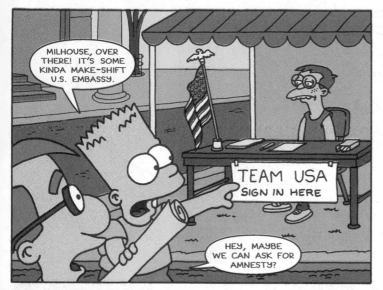

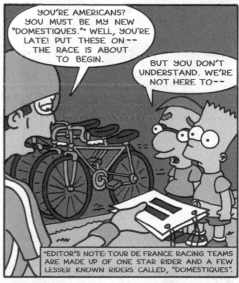

*EDITOR'S NOTE: TOUR DE FRANCE RACING TEAMS ARE MADE UP OF ONE STAR RIDER AND A FEW LESSER KNOWN RIDERS CALLED, "DOMESTIQUES".

SOON...

THESE GUYS ARE *PATHETIC!* THIS IS THE LAST TIME I GET MY DOMESTIQUES OUT OF THE *YELLOW PAGES.*

COME ON, MILHOUSE, WE'RE *LOSING* THEM.

I'VE GOT *CRAMPS* IN MUSCLES I DIDN'T EVEN KNOW I *HAD.*

THERE THEY GO!

HEY, IF YOU'RE GOING TO *QUIT* YOU NEED TO RIDE IN THE "BROOMWAGON."* AND YOU CAN *FORGET* SEEING ANY OF THE PRIZE MONEY! AND ANOTHER THING, THE *ENDORSEMENTS* ARE ALL MINE.

*EDITOR'S NOTE: THE "BROOMWAGON" IS THE VAN IN WHICH ALL RIDERS WHO CANNOT FINISH THE TOUR DE FRANCE RIDE IN WHEN THEY HAVE GIVEN UP. INFORMATIVE, AREN'T WE?

MEANWHILE...

THANKS TO MR. TEENY, THE CAST OF EURO-KRUSTY-LAND'S CHIMPTASIA, AND AN UNLOCKED LIQUOR CABINET, MCBAIN AND THE BOYS *VOTED ME OUT* OF THE TIMESHARE...

ALL OF FRANCE WANTS ME TO PAY BECAUSE OF SOME *SILLY LITTLE SIDE EFFECTS* FROM EATING MY BURGERS.

WELL, I'LL SHOW THEM ALL! I'LL BLOW THEIR BERETS OFF WITH THIS HASTILY PLANNED *PUBLICITY STUNT!*

EEEW...ON SECOND THOUGHT, THIS COULD TURN INTO MY VERY LAST PRATFALL.

MEANWHILE DOWN BELOW...

WELL, MILHOUSE, IT LOOKS LIKE TOURISTS AREN'T THE *ONLY* ONES THIS PLACE ATTRACTS. COME ON PAL, WE'VE GONE THIS FAR. *NOTHING* CAN STOP US *NOW!*

UH, BART, I'M NOT SO SURE ABOUT THAT.

MIMES!! THEY'LL *NEVER* LET US PASS WITHOUT HOURS OF WORDLESS MIMICRY.

MIMES DE PARIS

BART, WHAT'LL WE DO? THEY'RE SO...*NEEDY!*

WHAT'S THE *ONE THING* THAT ALL MIMES ARE MORE SENSITIVE TO THAN ANYONE ELSE IN THE WHOLE WORLD?

CRITICISM AND INDIFFERENCE?

EXACTLY.

YOUR PALM WORK IS *SHODDY,* YOUR TUG OF WAR TECHNIQUE IS *BLAND...*

HELP ME OUT HERE, BUDDY.

UH, YOUR *CHILDISH* PANTOMIMES FILL ME WITH *ENNUI.*

ELEVATOR

THAT WAS CLOSE. LET'S JUMP IN THE ELEVATOR! IT'S THE ONLY WAY WE'LL *CATCH* THEM!

AH, GENTLEMEN, I SEE YOU HAVE MANAGED TO KEEP OUR APPOINTMENT.

DING!

WE MADE IT.

THERE THEY ARE, BART.

AY, CARAMBA! EITHER I'M HALLUCINATING FROM THE THIN AIR OR THAT MAN IN THE CLOAK IS--

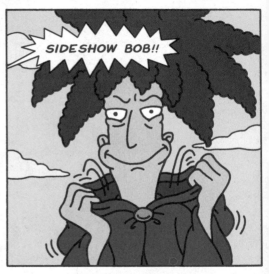

SIDESHOW BOB!!

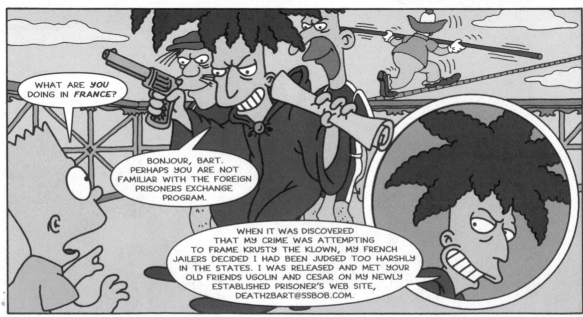

WHAT ARE YOU DOING IN FRANCE?

BONJOUR, BART. PERHAPS YOU ARE NOT FAMILIAR WITH THE FOREIGN PRISONERS EXCHANGE PROGRAM.

WHEN IT WAS DISCOVERED THAT MY CRIME WAS ATTEMPTING TO FRAME KRUSTY THE KLOWN, MY FRENCH JAILERS DECIDED I HAD BEEN JUDGED TOO HARSHLY IN THE STATES. I WAS RELEASED AND MET YOUR OLD FRIENDS UGOLIN AND CESAR ON MY NEWLY ESTABLISHED PRISONER'S WEB SITE, DEATH2BART@SSBOB.COM.

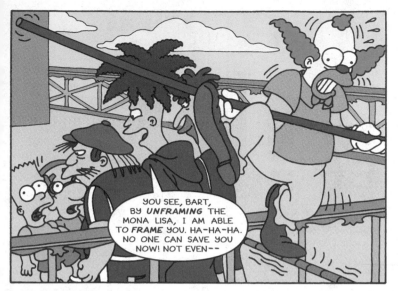

YOU SEE, BART, BY *UNFRAMING* THE MONA LISA, I AM ABLE TO *FRAME* YOU. HA-HA-HA. NO ONE CAN SAVE YOU NOW! NOT EVEN--

KRUSTY!!

HUH?

NO, NOT EVEN HIS ROYAL TRAVESTY, *KRUSTY THE--*

--KLOOOOWW!

THWACK!!

OOPS.

AIEEEE!!

UH-OH. DON'T BLAME ME! *I* DIDN'T DO IT!

YOU KNOCKED THEM ALL *UNCONSCIOUS* WITH *ONE SWING!*

WAY TO GO, KRUSTY! YOU ALMOST TURNED HIM INTO *SIDESHOW SHISH-KA-BOB!*

IN A MOMENT...

KRUSTY, ON BEHALF OF **ALL OF FRANCE,** I WANT TO THANK YOU FOR RETURNING OUR **BELOVED** MONA LISA TO US.

I COULDN'T HAVE DONE IT WITHOUT MY TRUSTY CRIME FIGHTING PARTNER...

Le POLICE

I KNEW KRUSTY WOULDN'T FORGET TO SHARE THE GLORY.

...THE SOON TO BE PATENTED "KRUSTY KRIME KLUBBER 2000." COMING TO A "CENTER DU SHOPPING" NEAR YOU FOR A REASONABLE PRICE. **HO-HEY-HEY-HO!**

HEY, WHAT ABOUT US, BART? KRUSTY OWES US **BIG TIME!**

RELAX. I'M SURE HE WON'T FORGET ABOUT US.

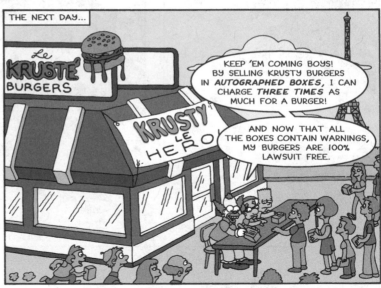

THE NEXT DAY...

Le KRUSTÉ BURGERS

KRUSTY LE HERO

KEEP 'EM COMING BOYS! BY SELLING KRUSTY BURGERS IN **AUTOGRAPHED BOXES,** I CAN CHARGE **THREE TIMES** AS MUCH FOR A BURGER!

AND NOW THAT ALL THE BOXES CONTAIN WARNINGS, MY BURGERS ARE 100% LAWSUIT FREE.

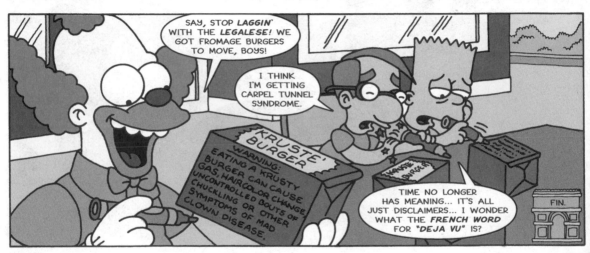

SAY, STOP **LAGGIN'** WITH THE **LEGALESE!** WE GOT FROMAGE BURGERS TO MOVE, BOYS!

I THINK I'M GETTING CARPEL TUNNEL SYNDROME.

KRUSTÉ BURGER WARNING: EATING A KRUSTY BURGER CAN CAUSE GAS, HAIRCOLOR CHANGE, UNCONTROLLED BOUTS OF CHUCKLING OR OTHER SYMPTOMS OF MAD CLOWN DISEASE.

TIME NO LONGER HAS MEANING... IT'S ALL JUST DISCLAIMERS... I WONDER WHAT THE **FRENCH WORD** FOR **"DEJA VU"** IS?

FIN.

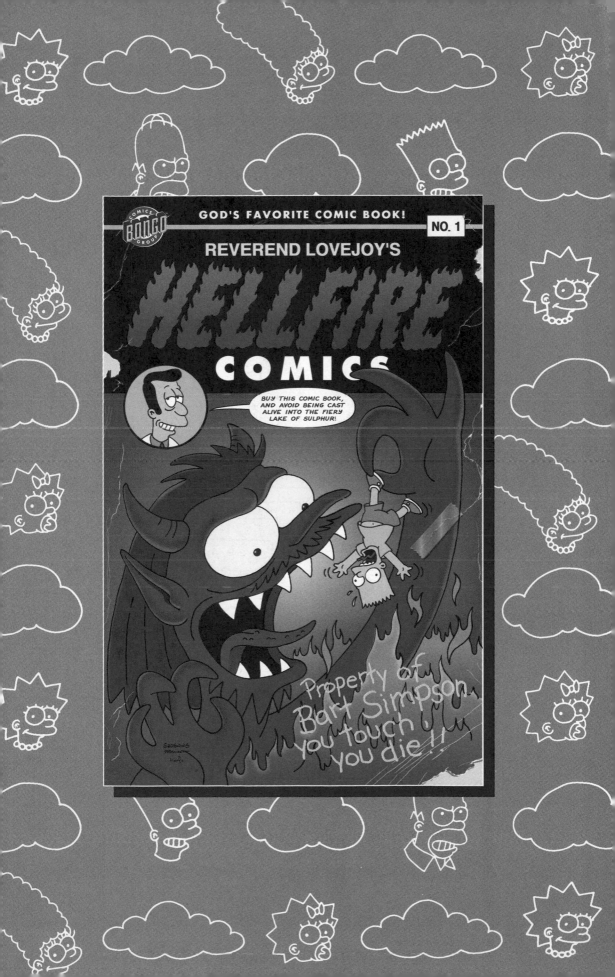

WELCOME, CHILDREN OF SPRINGFIELD! THE LORD WORKS IN *MYSTERIOUS* WAYS... AND NOW, EVEN IN CONVENIENT *COMIC BOOK FORM!*

A PLAGUE LURKS IN OUR COMMUNITY, A SWEEPING PESTILENCE KNOWN AS *HOOLIGANISM*-- RUFFIANS WHO CONSIDER "GETTING KICKS" MORE IMPORTANT THAN GOOD, REVERENT CITIZENSHIP.

BUT AS YOU'LL SEE, HOOLIGANISM HAS *DIRE CONSEQUENCES*. SO TAKE HEED MY TALE, LEST YOU TOO END UP LIKE...

CITIZEN SHAME!

Kids Advisory. Story with Moral!!

SCRIPT
DAN STUDNEY & JIM LINCOLN

PENCILS
BILL MORRISON

INKS
TIM BAVINGTON

LETTERS
JEANNINE CROWELL

COLORS
NATHAN KANE

PEW WARMER
MATT GROENING

MEET *BURT**, MODEL CITIZEN AND ALL-AROUND *GOOD EGG*...

MIGHT *I* DRY THE DISHES THIS EVENING, MOTHER?

AGAIN? WHAT A GOOD SON YOU ARE.

GOD BLESS US, EVERY ONE!

*ANY SIMILARITY TO ACTUAL SPRINGFIELDIANS IS PURELY COINCIDENTAL.

A BRIGHT AND EAGER STUDENT...

Shoot Me NOW!

"ASK NOT WHAT SPRINGFIELD CAN DO FOR YOU" an essay by Burt Sampson

THE FRIENDLIEST OF NEIGHBORS...

HI-DIDDLEY-HO, NEIGHBOR!

AND A HEY-DUM-DIDDLEY-SCRUM-DIDDLEY-OCIOUS TO YOU TOO, MR. LANDERS!

If you say it loud enough, you'll always sound precocious!